D1590646

POSTCARD HISTORY SERIES

Berrien County

in Vintage Postcards

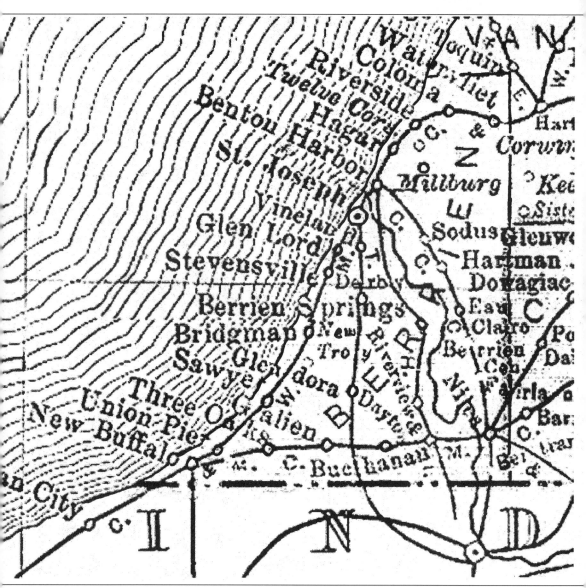

This 1895 map of Berrien County shows Lake Michigan on the left, Indiana at the bottom, Cass County on the right, and Van Buren at the top. Some villages such as Derby, Vineland, and Glendora were developed as nothing more than station stops for the Michigan Central Railroad on the St. Joseph-Galien Branch.

POSTCARD HISTORY SERIES

Berrien County

IN VINTAGE POSTCARDS

Sherry Arent Cawley

ARCADIA

Published by Arcadia Publishing,
an imprint of Tempus Publishing, Inc.
3047 N. Lincoln Ave., Suite 410
Chicago, IL 60657

Printed in Great Britain.

Library of Congress Catalog Card Number: Applied For.

For all general information contact Arcadia Publishing at:
Telephone 843-853-2070
Fax 843-853-0044
E-Mail sales@arcadiapublishing.com

For customer service and orders:
Toll-Free 1-888-313-2665

Visit us on the internet at http://www.arcadiapublishing.com

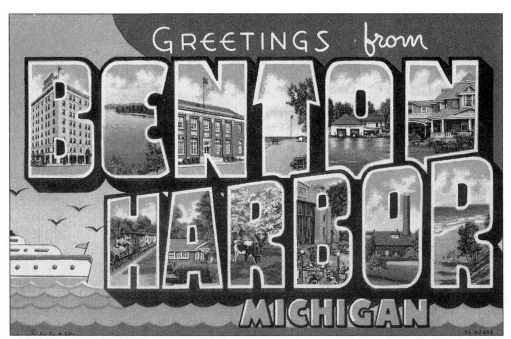

This large-letter, linen card of Benton Harbor shows pictures of other postcards within each letter. They include Lake Michigan, Hotel Vincent, Benton Harbor High School, and three views of the House of David.

CONTENTS

ACKNOWLEDGMENTS

In attempting to bring a book of this nature to life, it takes the generous cooperation of a number of people. My good fortune is having numerous relatives who grew up in Berrien County still living. A special note of grateful appreciation goes to Alma Arent, Roland Arent, Don Arent, Nathan Arent, Norma Turner, Norris Arent, Floyd Weber, and John Smith, who were so generous with their time and support. Thanks also goes to Sandy Gann for loaning us the real photo postcard of her grandparents.

Others who were exceptional in their help include Harold A. Atwood of Benton Harbor, a local historian; Robert C. Myers (Bob), curator of the 1839 Courthouse Museum in Berrien Springs; William Beverly (Bill), curator of the North Berrien Historical Museum in Coloma; and Rick Rasmussen, owner of the Paw Paw Lake Store in Coloma and an author of local history books. Museum exhibits that proved invaluable were found at the Fort St. Joseph Museum in Niles and Mary's City of David Museum in Benton Harbor.

A special comment is appropriate regarding my strong sense of personal historical affiliation with Berrien County. Although my birthplace is Benton Harbor, my first relatives in Michigan Territory were Francis R. Pinnell and his wife, Elizabeth; their oldest daughter, Rebecca, and her husband, Cyrus Hinchman (Harriet, their oldest daughter was my great-great-grandmother); Wesley Pinnell, brother to Francis, and his wife, Phoebe, sister to Elizabeth; and families. They came by boat and wagon train from Virginia to Niles in 1835 and settled in Benton Township. Wesley and Phoebe died of cholera in Indianapolis, and Francis raised their six younger children with his own.

Although other relatives arrived in 1841, it wasn't until 1851 that Christian Arend, with his children and second wife, came to America from Germany. Christian's son, Daniel Arent, with his wife, Henrietta Kniebes, raised 15 children in Bainbridge Township. The two oldest boys, Peter and Frank C. (my great-grandfather), married the two oldest girls, Louise and Mary, in the Koerber family.

So, my relatives really were true pioneers who helped to develop Berrien County from the southern portion of the county to the most northern end. Along with them, this book belongs to my grandparents, Frank A. Arent and Margaret L. Smith, who instilled in me that awareness of heritage and family pride; my father, Roland, who perpetuated that awareness; and my husband, Richard, who has put up with it.

INTRODUCTION

The beginnings of Berrien County go back to the Northwest Territory, when the French came down from Canada to explore the territory around the Great Lakes for new fur trade routes. We know that Ft. Miami was built at the present site of St. Joseph, at the mouth of the St. Joseph River in 1679. The French also established Fort St. Joseph near the city of Niles in 1691. Because this area was controlled by the French, Spanish, English, and Americans after the Revolutionary War, it became known as "The Land of Four Flags." The county flag adapted this theme in 1967.

Over 500 square miles was cut away from Lenawee County in 1829 and named in honor of John M. Berrien of Georgia, an attorney general in President Andrew Jackson's Cabinet. The survey that was done by Lucius Lyon in 1829 is still the basis for most of the township lines. Originally there were only three townships, consisting of Berrien, Niles, and St. Joseph. Today there are about 22 townships, 8 cities, and 9 villages in Berrien County.

The earliest known settlers in the county came in 1820 to set up a missionary school for the Indians. Today it is considered the tenth most populous county in the state.

Not only does one side of the county consist of 42 miles of Lake Michigan shoreline, but it also has 3 major rivers—the St. Joseph, Galien, and Paw Paw Rivers—and about 86 inland lakes, the largest being Paw Paw Lake. Paw Paw Lake covers 1,200 acres, and is about 3 miles long and 1.5 miles wide at its widest point. No wonder the early settlers described the area as nothing but Indians, forests, and swampland!

The county seat originated in Niles, moved to Newberryport (later renamed St. Joseph), and in 1837 moved to Berrien Springs, where a county courthouse was built in 1839. In 1894, it was voted to move the county seat back to St. Joseph, where it has remained. In 1967, the county purchased the 1839 courthouse in Berrien Springs for use as a county museum. It is Michigan's oldest courthouse and the state's only surviving example of a mid-19th century county government complex.

The county is fortunate to have about 14 historical museums where you can see exhibits on early life in Berrien County.

Berrien is still the number-one county in the state in all fruit growing. For over one hundred years, they have ranked number one or two in peaches, grapes, nectarines, brambles, and strawberries. There are over five hundred individual farms in the county. St. Julian Winery of Union Pier is the oldest, largest, and most awarded winery in the state.

After the forests were cleared away, after the land was tilled and found to have the best soil and climate for so many fruits and vegetables, and after people from other places discovered that this county made for a perfect vacation area, it's no wonder that for almost two hundred years, Berrien County has been a wonderful place to live or to spend time.

ABOUT POSTCARDS

Deltiology, the study of postcards, has been going on since the Austrian government produced the first governmental postal cards in 1869. In 1873, the first postal cards were released in the U.S. in New York, Boston, and Washington D.C. In 1893, the U.S. Government declared that all postcards, whether published by the government or private publishers, would be charged the same amount for mailing. Pictures could now be added to one side of the card, with the address on the other side.

Before World War I, millions of postcards were mailed each year throughout America and Europe. Today, accumulating postcards is one of the top three collecting hobbies. To help you enjoy this book, we'd like to share with you how we observe a postcard. First, we look at two things on the card: 1) the image or view on one side, and 2) the type or style on both sides of the printed card. These can tell us the age of the card and where it was published. Generally, there are six eras of postcard publishing that describe how the card was produced and formatted. Please note the dates are approximates and there is much overlapping. The six eras are: Pioneer, 1869–1898; Golden Age, 1898–1915; White Border, 1915–1930; Linen, 1930–1949; Chrome, 1949–1970; and Modern, 1970–Present. Prior to the 1960s, postcards were generally published as 3.5 inches by 5.25 inches in size. Today postcards are 4 inches by 6 inches or larger. Only pre-stamped postal cards remain in the smaller size.

Although you can't observe the backside here, items to look for include: the divided back, which was established in 1907 and allowed for a message to be shared with the space for the address; a postmark date; the postage stamp; the zip code, which didn't begin until 1943, and had only two digits until 1963; and the message itself.

Items to examine on the front include: clothing fashions on people; buildings, if they still exist, their architectural design, or how they look today; transportation from horse and buggy to automobiles, trains, trolleys and buses; roads, whether they are dirt or paved; bridges, style and how they are made; and format or style. Many publishers used a number/letter code to determine the date. For example: Curt Teich Co., Chicago, used letters to indicate the decade when a card was printed: A–1930s, B–1940s, C–1950s.

Deltiologists are fond of saying that anything and everything can be found on postcards. A postcard dealer will have his inventory divided into hundreds of topics. The general theme of this book is Berrien County, Michigan. The different postcard topics or subjects found herein include: advertising, artist signed, banks, banner, boats, bridges, caves, chromes, churches, city buildings, colleges, court house, exaggeration, fires, flowers, generic, greetings, hotels, houses, humor, lakes, large letter, libraries, linens, monuments, parades, parks, piers, post office, railroad, real photo, resorts, restaurants, retail stores, rivers, schools, sports, theaters, transportation, and views.

By collecting postcards and studying the age and topic of each card, we have an imaginative and fun way to study history. They also generate memories, stories, and debates. We hope you enjoy viewing these postcards as much as we've enjoyed collecting them.

One
FOUR FLAGS AREA

Niles is the center of the Four Flags area and was the first area in the state to be developed. The first permanent settlers bought land from the U.S. Government in 1829, and named it after the editor, Hezekiah Niles, of a Quaker weekly paper in Baltimore, Maryland. It was incorporated as a village in 1935, and was the first city in Berrien County. Numerous manufacturers have prospered in Niles over the years, including Simplicity Pattern Company, the French Paper Company, and National Cable and Manufacturing Company (now National Standard). In the early 1900s, Michigan Central Railroad transferred its train classification and car repair facility to Niles. Numerous famous people call Niles their birthplace. Aaron Montgomery Ward was raised in Niles and created a small mail-order business in Chicago, John and Horace Dodge moved to Detroit and built their first automobile in 1914, Ring Lardner was a sportswriter and author who began his career writing up sporting events for the *Niles Sun*, and Tommy "James" Jackson and his band, the Shondell's, became one of the most popular bands in the late '60s.

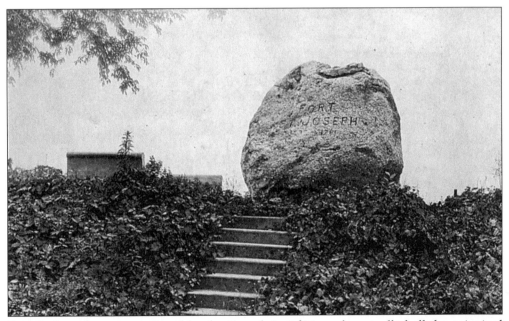

Fort St. Joseph was completed by the French in 1691, and controlled all the principal Indian trade routes in sovereign Michigan. The fort became a British outpost in 1761, but in 1763, Chief Pontiac seized the fort in an Indian uprising. In 1776, the United States flag flew over the fort, and in 1781, Spanish raiders ran up the Spanish flag for a short time before being replaced once again with the U.S. flag.

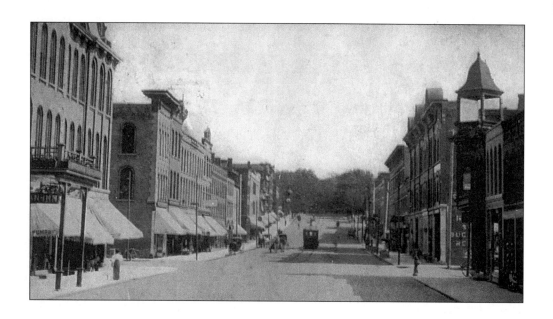

Postmarked 1909 and 1916, these two views show almost the same scene on Main Street with a few subtle differences. Observe the horse and buggies with the trolley car above and the cars below. Also note the street lamps in the lower view.

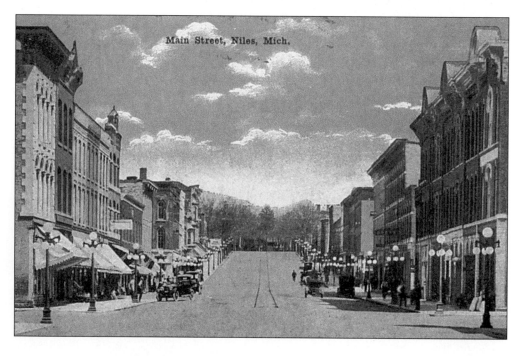

Main Street, Niles, Mich.

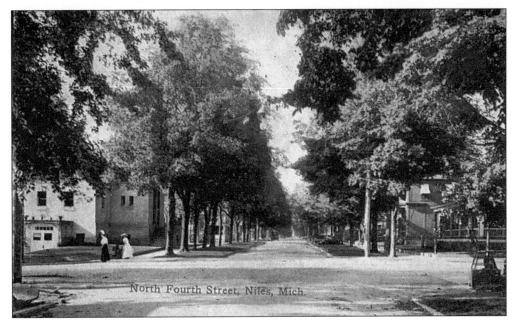

North Fourth Street, Niles, Mich.

Postmarked 1910, the street scene shown here is of North Fourth Street at Main Street. The building on the left is the old Carnegie Library. Today it is used as the tourist information center and the Niles Chamber of Commerce. The new library is located behind the Chapin Mansion that is now city hall.

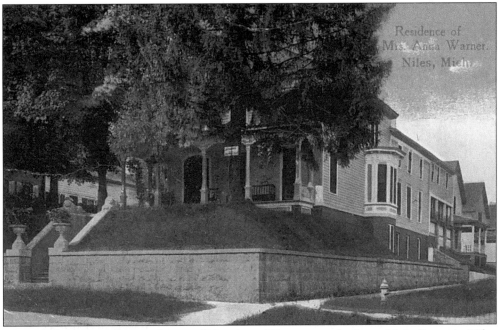

Residence of Mrs. Anna Warner. Niles, Mich.

Postmarked 1915, this residence of Mrs. Anna Warner was built on Main Street in Niles on the east side of the St. Joseph River. This lovely home, built in the Greek Revival architectural style in the early 1850s, is still a private residence. For almost 150 years, the lions at the top of the steps continue to greet all those who enter here.

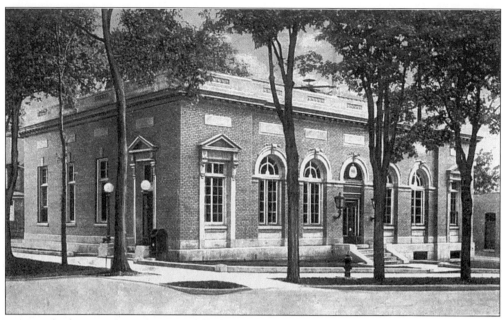

Postmarked 1917, the Niles Post Office is located at Third and Main Streets. It was built in 1909 at a cost of about $40,000. Notice the different styles of outdoor lamps that grace the entrances. The overhead light at the front entrance was added on with the use of electricity. The trees are gone to make room for parking, and it is now used as an office building.

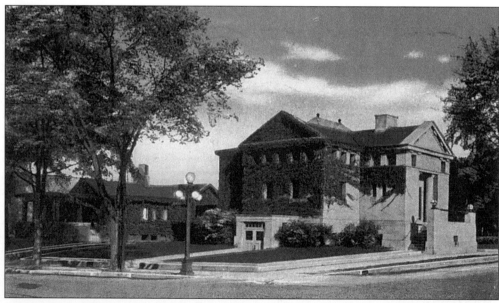

Postmarked 1947, the Carnegie Library was the first public library in Niles. The building was made possible through a $15,000 grant from the Andrew Carnegie Foundation. It opened in 1904 with five thousand books. Today it houses the city chamber of commerce. The new Niles Public Library opened in 1963.

Dr. Fred N. Bonine was born in Niles October 21, 1863. His father, Evan, was appointed regimental surgeon for the Second Regiment of the Michigan infantry. Fred was a classmate of automobile pioneers John and Horace Dodge. In 1887, he joined his father's practice as a medical doctor for eyes, ears, and throat. He became a nationally known ophthalmologist, seeing over two hundred patients a day. Excursion boats and later trains and motor coaches made as many as three trips a day to Niles filled with passengers who wanted to see Dr. Bonine. He had no appointments. Everyone waited in line and all patients paid $2 for the first visit and $1 for follow-ups. Beginning in 1900, he served four terms as mayor of Niles. He died August 22, 1941.

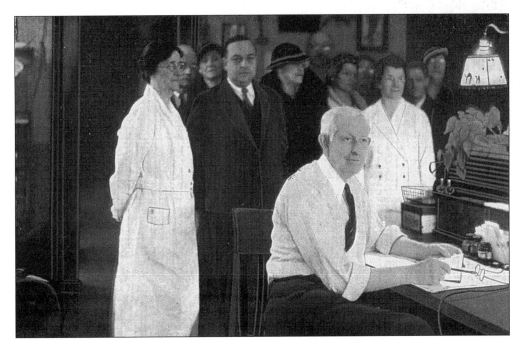

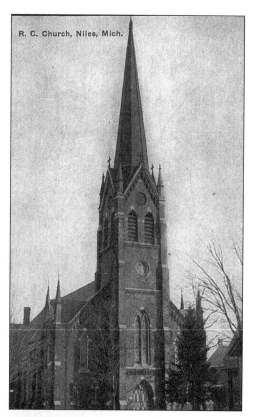

R. C. Church, Niles, Mich.

Here is St. Mary's Roman Catholic Church, which is located on the east side of the St. Joseph River on Lincoln Avenue. Although the construction began in 1866, the building was actually dedicated in 1870. The Gothic tower was added in 1890. There is a historic marker outside the church, adding it to the State Register of Historic Sites list.

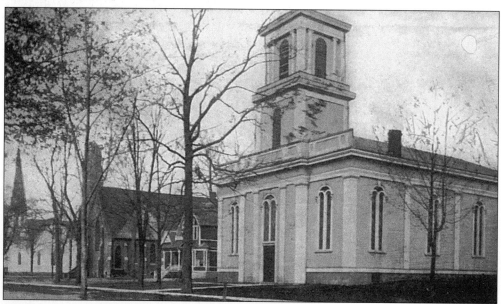

This card was published pre-1907 with an address-only backside. Of the three churches shown, starting at Fourth Street and Broadway, the Trinity Episcopal Church is the only one that is still using the same building. The church was organized in 1834, and the English Gothic church was built in 1858, making it the oldest church structure in Niles.

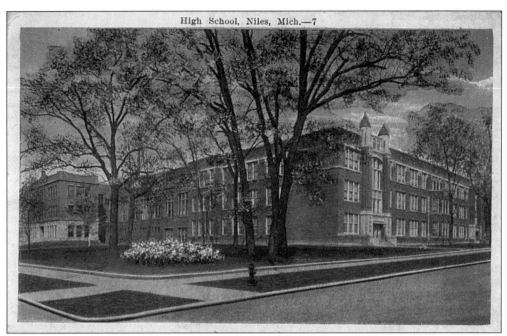

This white border card shows how the Niles High School looked in the 1930s. The construction of the school was completed in 1912. Located across from the old Carnegie Library, it was rebuilt in 1956.

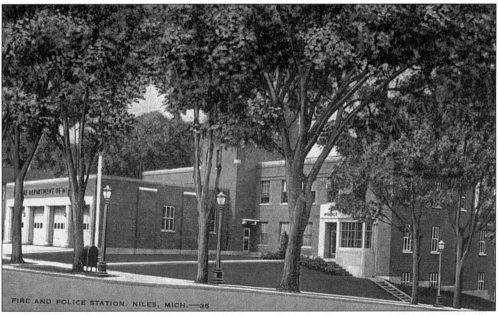

FIRE AND POLICE STATION, NILES, MICH.—35

Located at Third and Cedar Streets, the fire and police station in Niles are still in the same spot. Although it was unusual for the two departments to be combined in the same building, it was cost-effective. When originally built, it was advertised as a "completely modern and up-to-date building." Fortunately, it has been updated and renovated over the years.

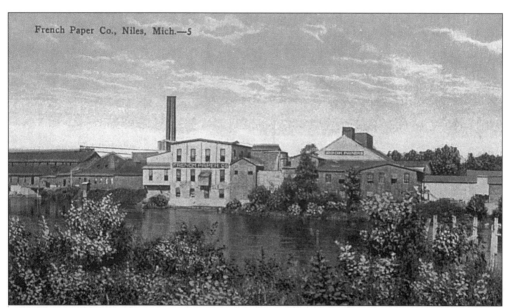

The Michigan Wood and Pulp Company was established in 1871. In late 1880, Joseph W. French purchased it, and eventually changed the name to the French Paper Company in 1904. Still in business today, with about one hundred employees, they make newsprint paper, paperboard, paper plates, and other office products. It is not only the oldest company in Niles, but also the oldest family-owned and operated business in Michigan.

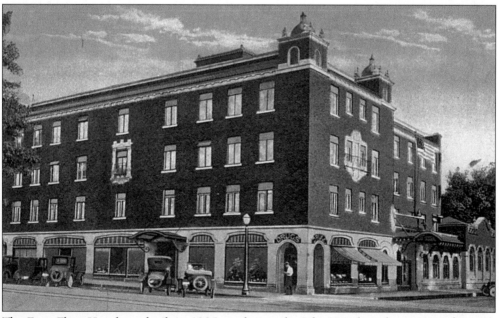

The Four Flags Hotel was built in 1925, replacing the Pike Hotel, at the corner of Fourth and Main Streets. It was the first business in the area to utilize the name Four Flags. At a cost of $350,000, it was considered very modern and supposedly was host to such personalities as Eleanor Roosevelt, Knute Rockne, Al Capone, and Truman Capote.

The National Printing and Engraving Company. in Niles was built to compete with the French Paper Company. Located on the same side of town, this company is no longer in business.

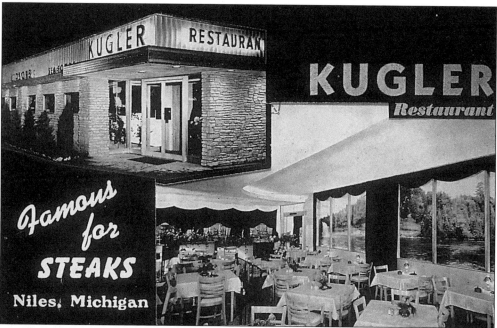

The Kugler Restaurant was located on North Fifth Street. Besides having good food, they were also well known for their full-size photographic murals on the walls. They were scenes of the St. Joseph River and, at first sight, one thought they were actually looking out a window at the water. They had an excellent bakery and were open every day except Monday.

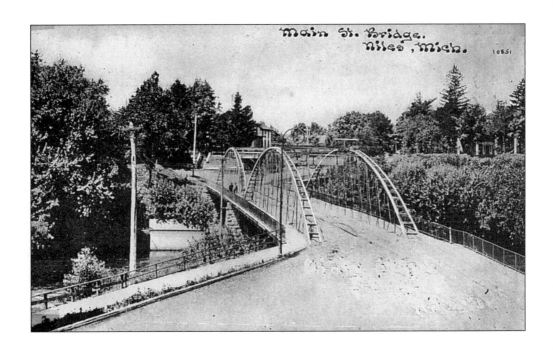

The Main Street Bridge was originally built across the St. Joseph River before the days of automobiles, when horse-drawn buggies and oxen-driven wagons were the common modes of transportation. The bridge was too light and too narrow for the increasing traffic of cars and trucks and had to be replaced.

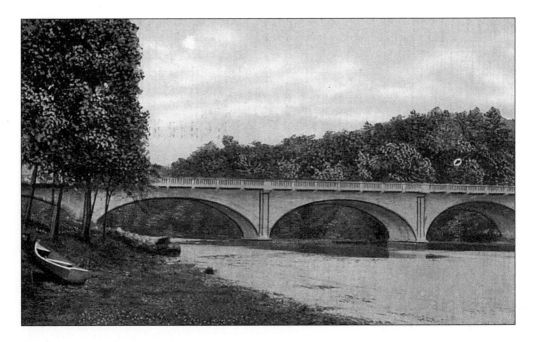

Located just off North Fifth Street on Dey Street, this sandstone Richardsonian Romanesque depot was built in 1891–92. It was designed by Detroit architects Spier and Rohns and cost over $30,000. It had a general waiting room, a smoking room, a dining room and kitchen, and a baggage and express room. There was also an apartment over the kitchen/dining room for the kitchen manager. The kitchen was closed in 1920. The depot has appeared in three movies: *The Continental Divide* starring John Belushi, *Midnight Run* with Robert DeNiro, and *Only The Lonely* with Maureen O'Hara and John Candy. Since 1974 it has been used as an Amtrak station and was restored in 1988.

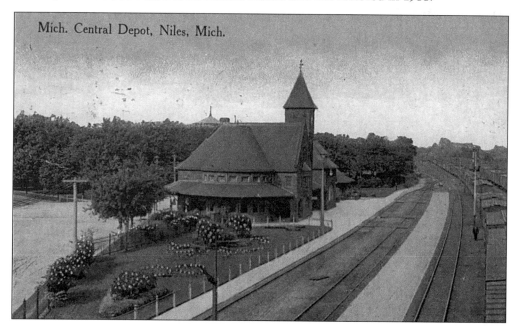

Mich. Central Depot, Niles, Mich.

In anticipation of many visitors coming through Niles during the Columbian Exposition in Chicago in 1893, a formal garden and park was established with John Gipner as the gardener and caretaker. He would pin a flower on all the women passengers when they came through Niles. Gipner also furnished flowers for the Michigan Central Railroad dining cars. Niles became known as the Garden City.

Postmarked 1914, this card shows people enjoying an afternoon in the public park in Galien. The village was named after the township and the Galien River, which was named after Rene de Galinee. He was a French priest and mapmaker for the missionaries who came to Michigan as early as 1670.

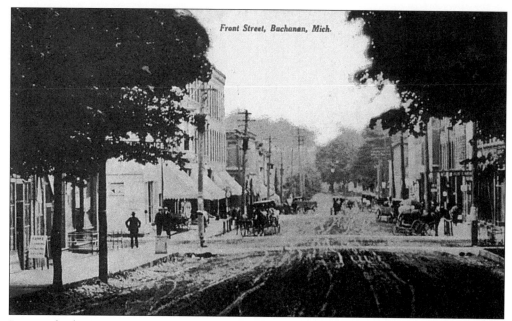

Front Street, Buchanan, Mich.

Postmarked 1909, Buchanan was incorporated as a village in 1858 and a city in 1929. The village was named after Senator James Buchanan, who had helped the Michigan Territory become a state. In an area that was filled with thick forests as well as flat prairie land, it didn't take long for many businesses such as dry goods, blacksmith, furniture makers, tailors, shoemakers, and dressmakers to open on the main street.

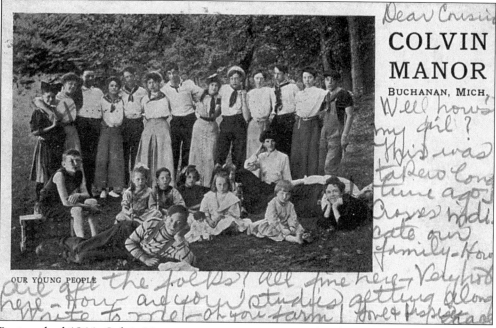

COLVIN MANOR

BUCHANAN, MICH.

OUR YOUNG PEOPLE

Postmarked 1911, Colvin Manor was a retreat just outside of Buchanan. We don't know who the people are in the card, but the sibling rivalry is very subtle, with the writer putting a cross on her blouse and another one across her brother's face.

21

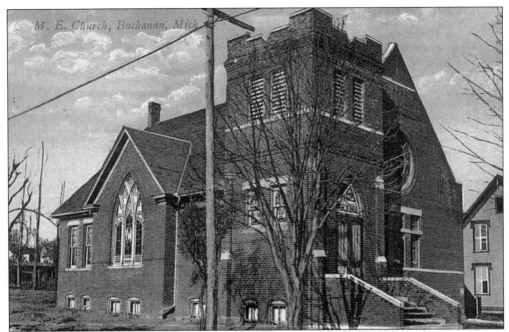

This is an early view of the Methodist Episcopal Church in Buchanan. Many early settlers in Berrien County were Lutheran or Episcopal in Germany and England, but neither denomination was strong in America at the turn of the century. The Methodists called themselves Methodist Episcopalians before separating into two separate denominations.

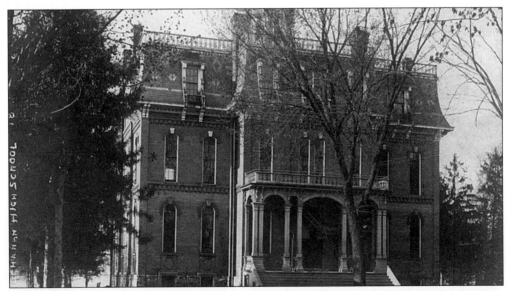

Postmarked 1910, this was the Buchanan High School for over 50 years. It was built in the Italian Revival architectural style with a square building, a short sloping roof, round arched windows that were long and narrow, and double arched front doors. When the new high school was built in front of this building, all but the lower level was torn down and was used as the heating plant.

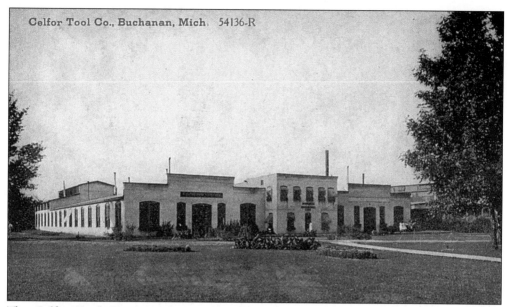

Celfor Tool Co., Buchanan, Mich. 54136-R

The Celfor Tool Company was originally called the George Rich Company. Taking advantage of the electric power plant recently built on the river, the company made a new kind of steel drill to be used in building railroad tracks. In 1907, Eugene B. Clark bought the Rich Company and changed the name to Celfor Tool. They also made axles for the auto industry.

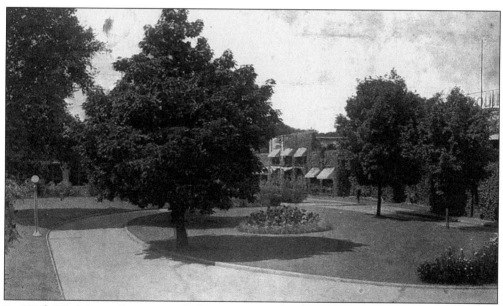

In 1916, Clark brought numerous businesses in the area under one company. He called his business Clark Equipment Company. They made axles and transmissions for army trucks, forklift trucks to carry big loads, and heavy construction machinery to build highways and bridges around the world. Their world headquarters was in Buchanan until the 1970s, when they moved to South Bend, Indiana. Today, the buildings are used by various small businesses.

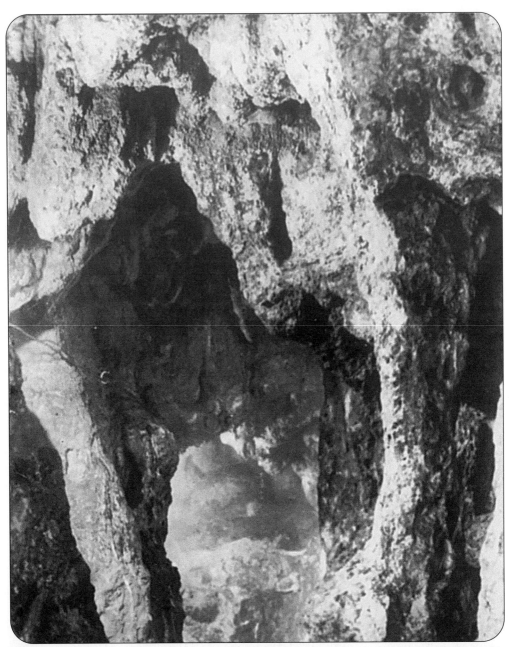

Here is a real photo of Bear Cave. It is located about 4 miles north of Buchanan, on the west side of the St. Joseph River. It is the only true cave in Michigan. Believed to be nearly 30,000 years old, various minerals seep through the walls of rock into the main room, creating shades of green, brown, red, and black. There are also petrified leaves, roots, and other vegetation in the walls and stalactites hanging from the ceiling. According to the native Indian tribe, the Potawatomi, legends claim that bears, wolves, and the Indians used the caves. It was also believed to be a way station for the Underground Railroad before and during the Civil War. About 1915, the cave was used in a silent movie thriller, *Train Robbery*.

Two
BERRIEN SPRINGS

Early settlers began clearing the land north of Niles and reached the Berrien Springs area about 1829. At that time it was still considered Indian land and was named Wolf's Prairie after the Indian chief who called this area home. Before it was incorporated as a village in 1863, the residents decided to change its name to Berrien Springs because of all the natural springs that surrounded the community.

Andrews College has been an integral part of Berrien Springs since 1901. It attracts students from all over the world and has two fine museums on campus, the Natural History Museum and the Siegfried H. Horn Archaeological Museum. Berrien Springs is also home to the Berrien County Historical Association, housed in the 1939 Courthouse Museum. The complex also includes the 1870 sheriff's residence, the Bennett Forge and Blacksmith Shop, and the Murdock Log House, built in the 1830s. Situated on the St. Joseph River with Lake Chapin close by, the fishing is excellent. Chinook, coho, bass, and steelhead are some of the best catches of the day.

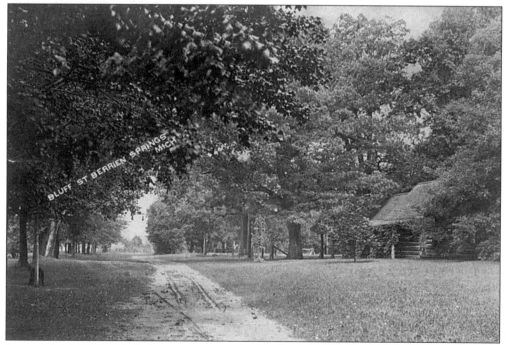

Postmarked 1908, Bluff Street runs on the bluff next to the St. Joseph River. The log cabins were probably built as summer cottages overlooking the river. They are still there, in use, and privately owned.

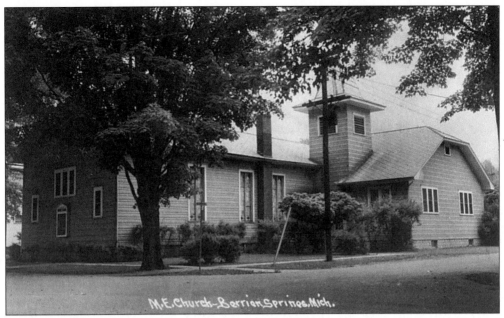

This is a real photo card of the Methodist Episcopal Church on West Mars and Kimmel Streets, probably taken in the 1940s. A new, larger church building was constructed behind this one, but it is still used by the church and looks basically the same.

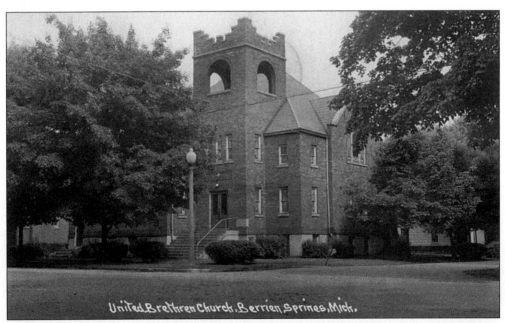

Postmarked 1947, the United Brethren Church was located on West Ferry and South Kimmel Streets, and was built about 1924. Today, it is a Spanish Seventh Day Adventist Church.

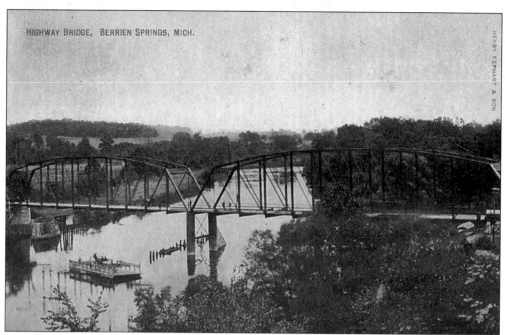

The first bridge across the St. Joseph River at Berrien Springs was built in 1843. Another wooden bridge was constructed in the late 1880s, but was replaced by this metal truss bridge in 1904. This bridge collapsed in 1948, while an A&P grocery semi-trailer truck was trying to cross the river. A temporary bridge was hastily constructed in late 1948, but was not replaced until 1995, making it the longest-lasting temporary bridge in Michigan.

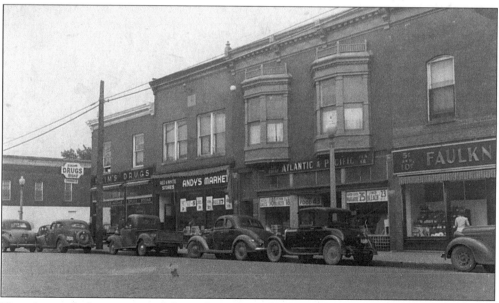

Here is a real photo postcard from the 1930s taken on Ferry Street, with Main Street in the background. Note the Atlantic & Pacific Tea Co. store next to Faulkner's 5 & 10 Cent Store. The building is still used for retail stores but the A&P is long gone.

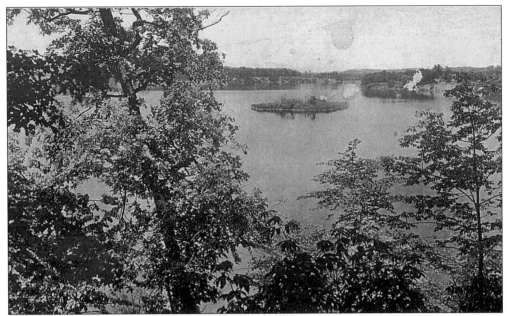

Postmarked 1930, this card is typical of many homes built around Lake Chapin that began to take in overnight visitors. As business increased, the homes became resorts or inns and were profitable for many years.

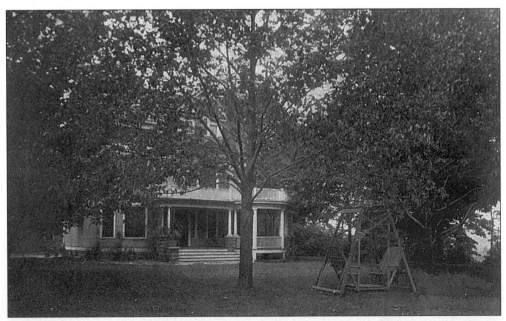

In 1908, the Indiana and Michigan Electric Company built a dam on the St. Joseph River near Berrien Springs, creating a lake. It was named Chapin Lake after Charles A. Chapin, son of Henry A. Chapin—a well known Niles resident and one of the founders of the Indiana & Michigan Electric Company. This scene is looking upstream with the left side of the card going toward the dam.

Edgar S. Pennell came to Berrien County in 1848 at the age of five. About 1879, he purchased 120 acres on the St. Joseph River and by 1895 was entertaining summer boarders at this home. Mr. Pennell added cottages around the main house and called their resort Pennellwood. They averaged 60 guests a week, and at the height of the season could accommodate 100. In the early days, guests would be greeted at the train station and escorted to the resort. It is located on Range Line Road about 1.5 miles south of Berrien Springs right on Lake Chapin. Pennellwood is still in business, complete with tennis courts and a swimming pool.

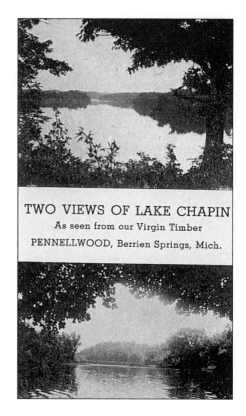

TWO VIEWS OF LAKE CHAPIN
As seen from our Virgin Timber
PENNELLWOOD, Berrien Springs, Mich.

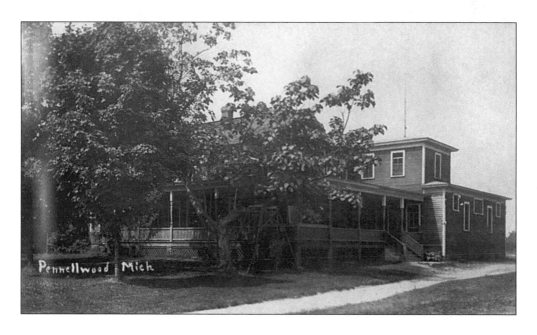

Pennellwood, Mich.

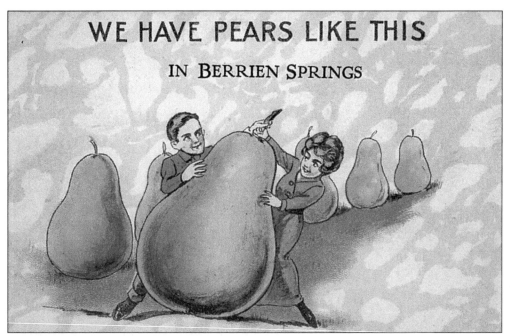

Postmarked 1916, this exaggeration card is also called a "generic" postcard. The publisher would use the same card and stamp different town names on the picture side of the card. It is also considered a humorous card as we watch the couple struggle with their pear.

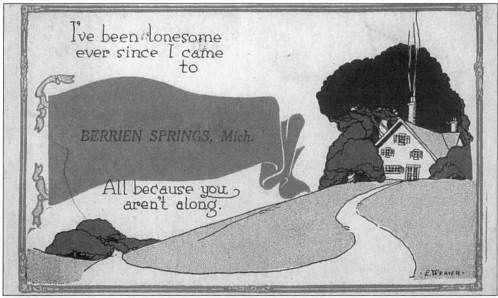

Postmarked 1923, here is another example of a generic postcard. This artist-signed card is part of a set of 16. The "banner" will appear on each card imprinted with a different town on each set. E. Weaver was a very prolific American postcard artist at the turn of the century through the 1930s. His designs, in sets of 8 to 32, are whimsical and humorous with many drawn in a simplified Art Nouveau style.

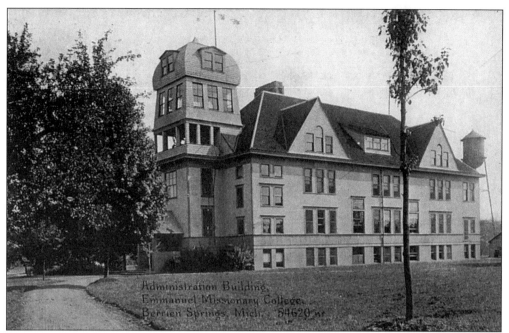

In 1874, the Seventh Day Adventist denomination started Battle Creek College in Battle Creek. In 1901, they moved the school to Berrien Springs and renamed it Emmanuel Missionary College. The church moved its Theological Seminary from Washington D.C. in 1959 and, shortly thereafter, combined the school under the name Andrews University. The school was named after John Nevins Andrews, a pioneer Adventist, who was the denomination's first official missionary to serve outside North America.

Postmarked 1937, one sees a view from the administration building of the campus, which grew from the original 272 acres to almost 1,600 acres. The note from a student on the backside states, "I'm working 10 hrs. a day and going to night school 4 nites a week. I don't have time to get lonesome."

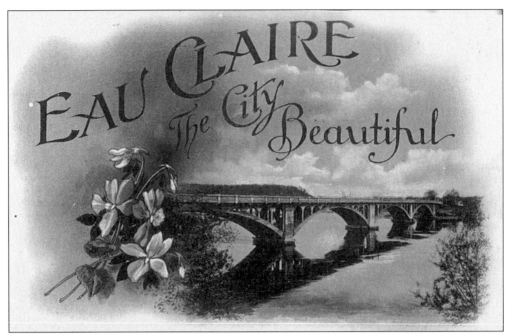

Here is a scenic large letter card. Eau Claire is a small village about 5 miles northeast of Berrien Springs. It was founded in 1837, and incorporated as a village in 1891. It was named for a small crystal-clear creek that flowed through the area in the 1860s. One has to smile when looking at this card because there is no river by Eau Claire and no bridge!

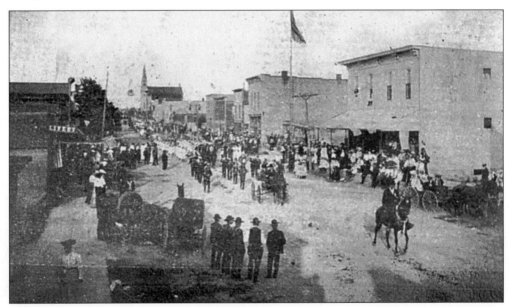

Postmarked 1907, this view is looking east down Main Street, probably of the town's Fourth of July parade. Remember this was taken prior to World War I, so any soldiers observed in the parade would have the Union uniforms of the G.A.R. The church that is visible in the background is still there.

Three
HARBOR COUNTRY

The Harbor Country of Berrien County is comprised mostly of the lakeshore communities south of St. Joseph to the Indiana state line. The 15 miles of beaches and sand dunes include the villages of Grand Beach, Michiana, New Buffalo, Union Pier, Lakeside, Harbert, Sawyer, and slightly inland, Three Oaks. Resting so near the tip of the boot around Lake Michigan, the area has always been part of the trade route, from the early days of trading furs with the Potowatomi Indians to the lumber industry, agricultural crops, and tourists using the ships to come back and forth from Chicago. Three Oaks has one of the three surviving brick passenger stations for the Michigan Central Railroad in Berrien County. Today one can drive the Red Arrow Highway from New Buffalo to Sawyer and find over 50 places to visit going through these villages. There's everything from antiques, dining, art galleries, Warren Woods State Park, specialty shops, and wineries where you can stop and taste before you buy. A great day trip, you can also spend the night in one of the excellent inns along the way.

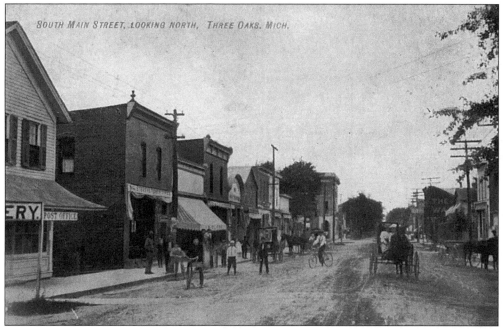

After closely viewing this South Main Street card, it will come as no surprise to know that today the Three Oaks Spokes Bicycle Museum is on Oak Street. It has a display of historic bicycles, a reference library, and rental bikes. They also have a brochure that will guide you on 12 area bicycle tours.

About 1880, Edward K. Warren purchased Chamberlain's General Store, where he had worked for many years. In 1883, he came up with the ingenious idea to replace whalebone stays in women's clothing by splitting turkey feather quills and binding them into elastic strips. He called his product "Featherbone." They also manufactured buggy whips. Warren Featherbone Co. closed its Three Oaks plant in 1957. The 1904 office building has been restored with a three-story lobby.

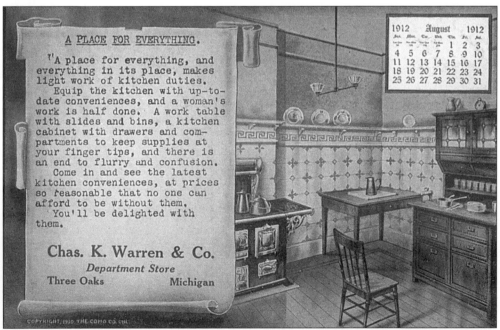

Here is an advertising and calendar card from the Chas. K. Warren & Company Department Store. The year on the calendar is 1912. This is the same store that was owned by Edward K. Warren before he created the Warren Featherbone Co.

"Three Oaks (Mich.) Against the World"

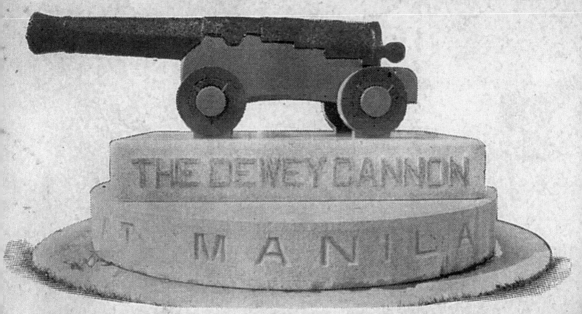

Captured (on Corregidor Island, Manila Bay) by U. S. R. C. McCulloch Nov. 7, 1898; presented by Admiral Dewey to National Monument Committee and awarded by them to Three Oaks July 14, 1899, for the largest pro rata contribution ($1,132.80) toward erection of monument in memory of soldiers and sailors who lost their lives during the Spanish war.
Mound dedicated by Pres. McKinley, Sec'y Long, Att'y-Gen. Griggs and Sec'y Hitchcock Oct. 17, 1899. Cannon unveiled by Helen Miller Gould in the presence of Gen. R. A. Alger June 23, 1900. E. K. Warren, H. Chamberlain, J. L. McKie, Com.

After the Spanish American War, Admiral George Dewey brought back an ancient Spanish cannon as a war trophy. The National Monument Committee decided to raise money for a war memorial by offering the cannon to the town that made the largest per capita contribution to the fund. This meant that small towns could compete with cities like New York and Chicago. Edward K. Warren was certain that Three Oaks could win the prize and reminded the town of its slogan, "Three Oaks Against The World." They raised $1,132.80, with an average of $1.41 for every man, woman, and child in the village. Papers all over the country carried the story of this small village entering the competition and on July 14, 1899, Warren received word that Three Oaks was the winner!

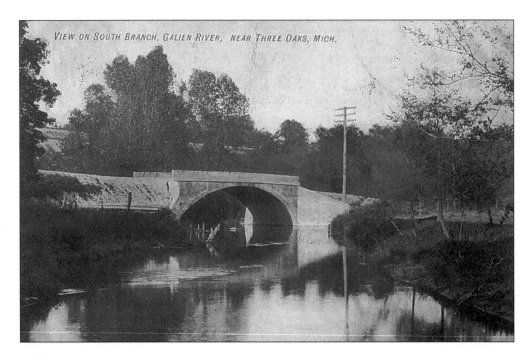

VIEW ON SOUTH BRANCH, GALIEN RIVER, NEAR THREE OAKS, MICH.

Here are two views of the Galien (pronounced 'Gah-leen') River Bridge. The Galien River is one of three major rivers that flow through Berrien County. This quiet river flows through the village of Galien up to New Troy. It then meanders through Warren Woods State Park—a primeval forest and wildflower sanctuary—down past Union Pier, crossing the Red Arrow Highway to New Buffalo, and into Lake Michigan.

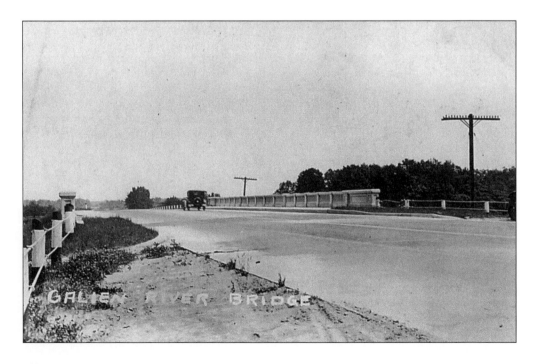

GALIEN RIVER BRIDGE

A real photo card, postmarked 1916, shows the main road to Grand Beach. About 1900, Floyd Perkins originally purchased the area to develop a hunting preserve. It didn't take him long to discover it would be more profitable to promote the area as a summer resort community. Perkins and his partner, George Ely, formed the Grand Beach Company.

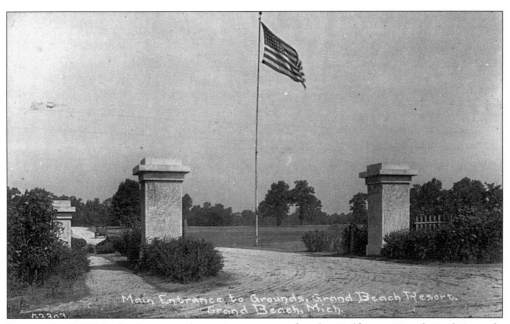

Postmarked 1915, this became the main entrance for the Golfmore Hotel. Built in only four months, this three-story building with twin towers and two-hundred guest rooms, opened on July 4, 1922. It also had a 27-hole golf course, horseback riding, tennis, and a dance orchestra—all of it for just $2 a day. Sadly, on the evening of November 19, 1939, the newly renovated and improved Golfmore blazed to the ground and was never rebuilt.

This structure was used as the civic center for Grand Beach in the 1930s. It also housed a pavilion for outdoor activities such as concerts and art shows. There was a small "tea room" restaurant at one end.

The Michigan Central Railroad came to New Buffalo in 1849 and ended its line there. Passengers had to get off and travel the rest of the way to Chicago by boat. Until 1852, when the railroad extended its line to Chicago, New Buffalo enjoyed being a real frontier boomtown.

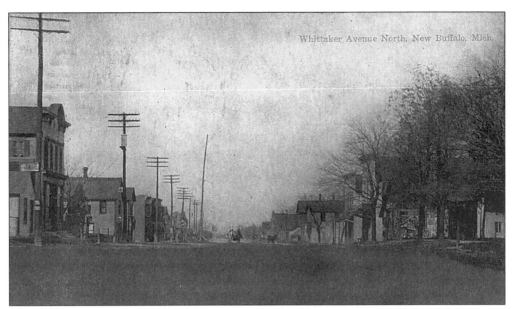

Dated 1913, this scene shows the main business street of New Buffalo looking west. Captain Wessel D. Whittaker incorporated the village of New Buffalo in 1836. His ship had been destroyed and run aground in the area in 1834. The captain was so impressed with the region that after he returned to his home in New Buffalo, NY, he came back with other investors interested in starting a new community on Lake Michigan.

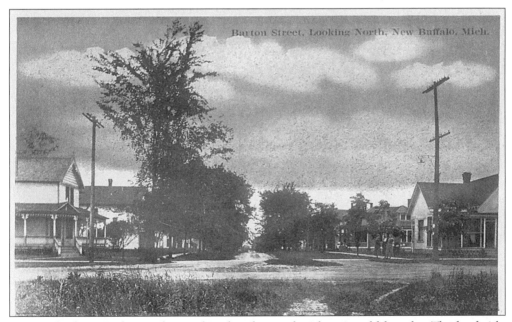

Postmarked 1918, this card is a white border card with a tinted blue sky. The backside states, "This is really a pretty spot. Mostly forest and right on the shores of Lake Michigan." Very little forest remains, but New Buffalo is considered the heart of the Harbor Country, its streets now lined with great specialty stores, restaurants, and art galleries.

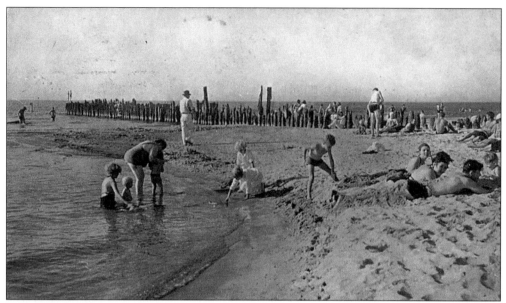

Postmarked 1947, the public beach at Lakeside Park is where the Galien River flows into Lake Michigan. Since the turn of the century, tourists from the Midwest have enjoyed spending their vacations in Berrien County. New Buffalo has a unique location situated on the shore of the Galien River and Lake Michigan.

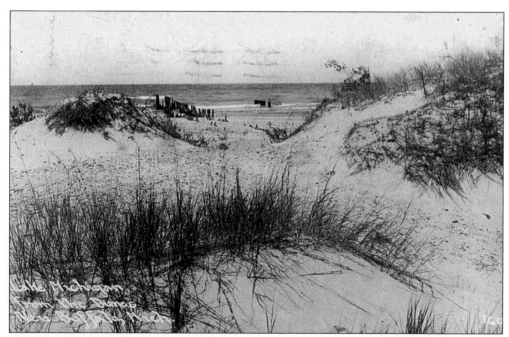

Here is a real photo postcard, postmarked 1938, showing Lake Michigan from the sand dunes at New Buffalo. Soft sandy beaches and sand dunes edge the 42 miles of shoreline in Berrien County.

The Berrien County Y.W.C.A. was organized at the turn of the century and officially became a part of the national organization in 1911. As part of their activities, they developed a summer camp at New Buffalo. It was very active in the 1930s through the 1950s. Forest Beach Camp could accommodate over one hundred girls at a time. Shown here are a dormitory, the crafts house, and the store where the girls could purchase small items, usually edible treats, during their stay.

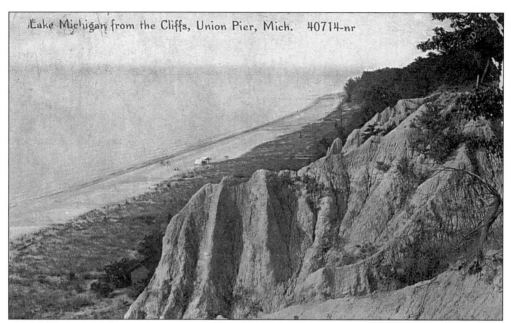

Lake Michigan from the Cliffs, Union Pier, Mich. 40714-nr

Originally called Townline, Union Pier was renamed by John Gowdy, who recognized the valuable resource of the local hard and softwood trees. In the early 1860s, Gowdy and his investors built a remarkable pier 600 feet out into Lake Michigan to transport the timber to Chicago. By the 1920s, the forests were depleted, but fruit was soon packed for transport and many tourist resorts were built in the area.

View of Ravine from Lake Michigan, Union Pier, Mich. 40700-nr

Postmarked 1923, this shows the variety of scenery from sand dunes to the sandy beaches close to the Inn at Union Pier. It was originally built as a summer resort that was the only kosher hotel in Union Pier. Today it has been renovated into 16 spacious guest rooms with a mix of Danish and Swedish antiques.

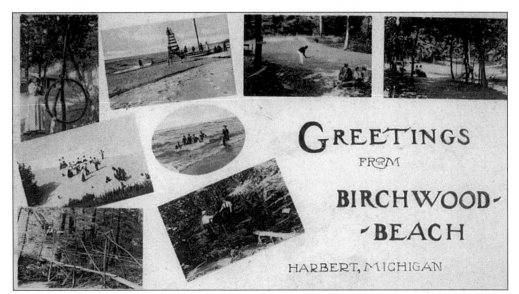

GREETINGS
FROM

BIRCHWOOD-
-BEACH

HARBERT, MICHIGAN

Here is another type of greeting card showing different shots of the area. Although the card is stamped "Birchwood Beach," the majority of the scenes shown are of other beaches and woods near Harbert. Part of Chickaming Township, the village of Harbert was named after an Evanston, Illinois, attorney who owned some local property and was instrumental in getting the railroad to stop in the area.

Postmarked 1933, these woods were named after Mr. And Mrs. Edward K. Warren of Three Oaks. In 1917, they founded a non-profit foundation and deeded about 311 acres of primeval forest to be preserved as a park and natural laboratory. It consists mainly of beech and maple trees, has a suspended wooden foot bridge over the Galien River, and is considered one of the best birding areas in Michigan.

43

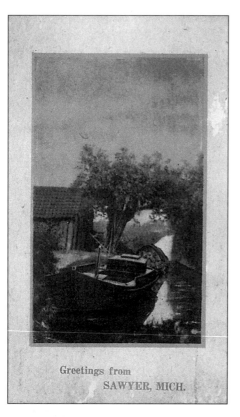

Greetings from
SAWYER, MICH.

Postmarked 1928 and stamped "Sawyer, Mich.," this generic card shows a boat on a canal. There are no canals around Sawyer, but the Galien River is very close by. The closest park is Warren Dunes State Park, but no one has ever seen a stream or creek that straight and narrow.

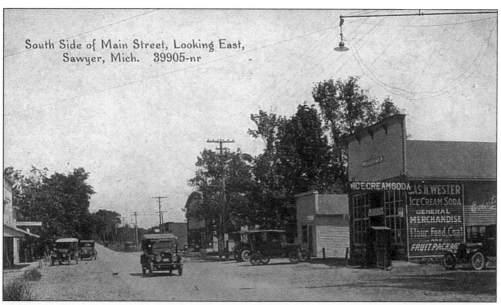

South Side of Main Street, Looking East, Sawyer, Mich. 39905-nr

This is a 1930s view of the downtown area of Sawyer looking east from the railroad tracks. Note all the items for sale at the general store and the telephone poles. Today most shops are located along the Red Arrow Highway and are as diverse as the Center of the World Woodshop Showroom, the Book Rack, and the Dunes Antique Center.

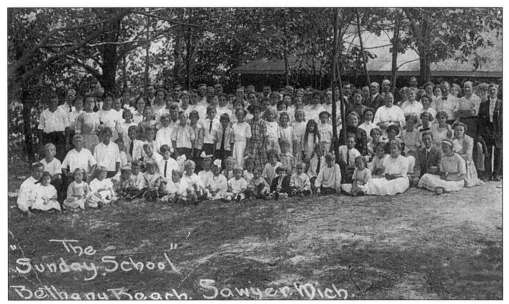

Postmarked 1908, this is obviously a church retreat at one of the nearby beaches. Many local churches in Berrien County would hold annual retreats at various resorts and camps along the Harbor Country. Quite a few denominations also maintained summer youth camps. On the backside, the writer states, "We all have a nice time. My mother was on a prar meating and we had a ice cream party."

Postmarked 1933, these woods were named after Mr. and Mrs. Edward K. Warren of Three Oaks. In 1917, they founded a non-profit foundation and deeded about 311 acres of primeval forest to be preserved as a park and natural laboratory. It consists mainly of beech and maple trees, has a suspended wooden foot bridge over the Galien River, and is considered one of the best birding areas in the world.

Notice all the trees around this beach house. In the early days, the lumber industry was very prevalent in this area. The village was actually named after Silas Sawyer, a lumberman from Ohio who built a steam sawmill in the area in 1853.

Postmarked 1950, Warren Dunes State Park was, and still is, a very popular park. It has 1.25 miles of shoreline and facilities for camping, cabins, boating, hiking, picnicking, windsurfing, hang gliding, and swimming in Lake Michigan.

Four
TWIN CITY/ST. JOSEPH

St. Joseph's history began almost one hundred years before the American Revolution. Four years after Father Jacques Marquette discovered the mouth of the St. Joseph River, the French explorer, LaSalle, built Fort Miami on the bluff around the river in 1679. As more white settlers moved inland into the surrounding area, the site became even more important in transporting goods in small boats over 150 miles inland. The trading post at the mouth of the river became the village of Saranac. The name was changed in 1831 to Newburyport, and finally in 1833 to St. Joseph. In 1891, the village officially became the City of St. Joseph. The first road that was opened from Detroit ended at the mouth of the St. Joseph River. Territorial Road, still existing, opened in 1836, and in the same year, E.A. Draper began publishing the *St. Joseph Herald*. It was the gateway to the west. People would come by stagecoach to St. Joseph and take steamer ships to Chicago. To accommodate all the tourists that were coming through town at the turn of the century, they built numerous large mineral bath hotels, and Silver Beach Amusement Park opened up. Much is gone or replaced, but St. Joseph still appeals to thousands of tourists every year.

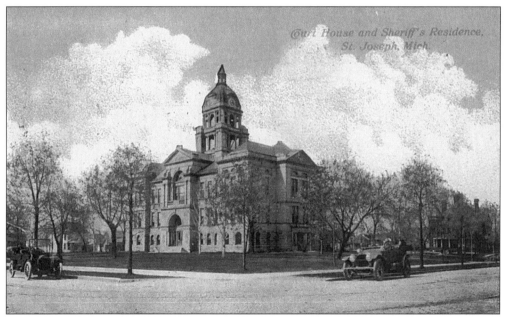

Postmarked 1913, this card of the Berrien County Court House shows the sheriff's residence on the right, which was part of the county jail. The court house was built in 1895, after St. Joseph regained the county seat from Berrien Springs.

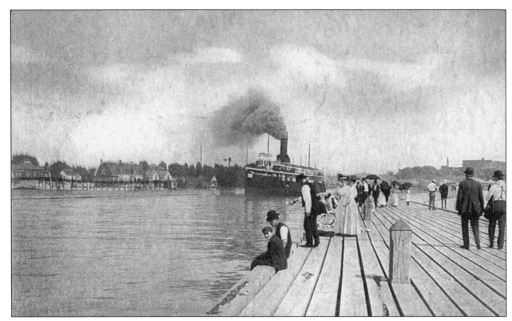

Postmarked 1923, this is a typical scene that visitors on the Graham & Morton steam ships would see on the south pier. Directly to the left of the ship is the Coast Guard station, and you can view the catwalk out to the North Pier lighthouse.

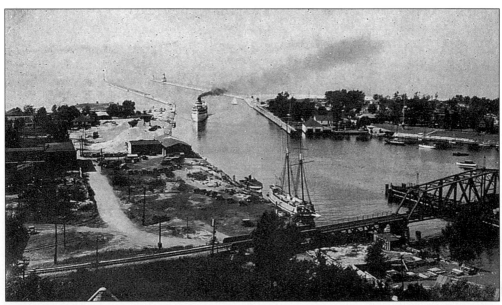

Postmarked 1936, one sees a steam ship coming into the St. Joseph harbor. The swing bridge for the Pere Marquette Railroad was built in 1909 and is still there. One can also see the North Pier lighthouse beyond the ship and the Coast Guard station to the right of the ship.

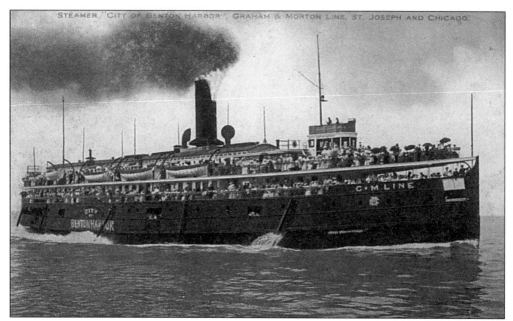

The Graham and Morton Steamship Line was organized in 1880. By 1890, the passenger steamship *City of Chicago* was sailing between Chicago and St. Joseph, and in 1893, the companion ship *City of Benton Harbor* began running. Both ships were making three round trips a day. By 1900, over 200,000 passengers had sailed into St. Joseph's port. It was the best mode of transportation from Chicago well into the 1930s.

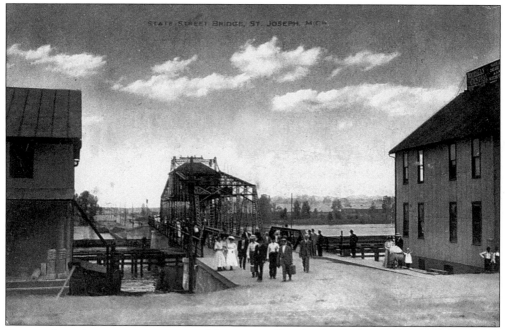

Due to changing transportation and heavier traffic, this bridge was removed when they built the Blossomland Bridge. Local natives still refer to the new bridge as the State Street Bridge or Highway M63 Bridge.

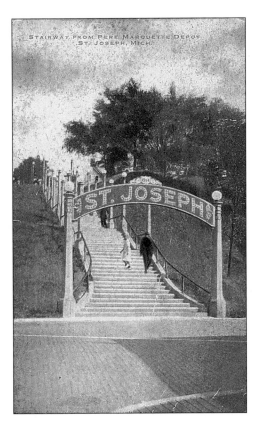

Postmarked 1921 and 1924, this stairway went from the Pere Marquette Depot to the foot of Broad Street and Lake Boulevard. The PMRR became the Chesapeake & Ohio Railroad. One had to be strong and hardy to climb over 75 steps to the top of the hill. Today the depot is a restaurant. Cooper Wells & Co. was an early knitting factory that produced seamless hosiery. When the building was torn down, the area became known as Whirlpool Field.

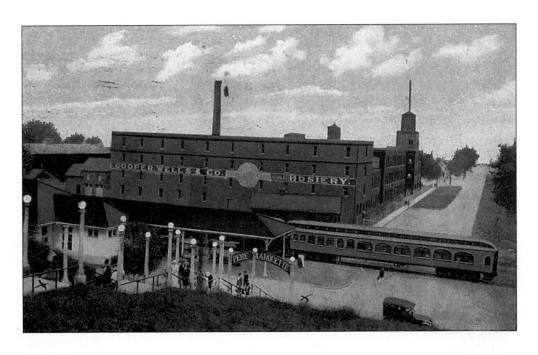

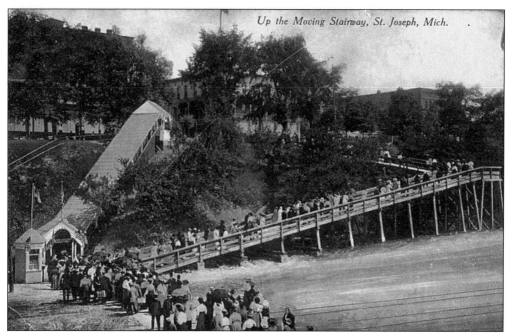

Up the Moving Stairway, St. Joseph, Mich.

To accommodate the ever-increasing number of tourists who wanted to partake of the mineral springs water in St. Joseph and Benton Harbor, a "moving staircase" was installed at the foot of the bluff at Vine Street to Lake Boulevard where the Maids of the Mist Fountain stands. It cost a penny to ride up or down. If you walk on the edge of the hill today, you can find patches of asphalt where the steps used to be.

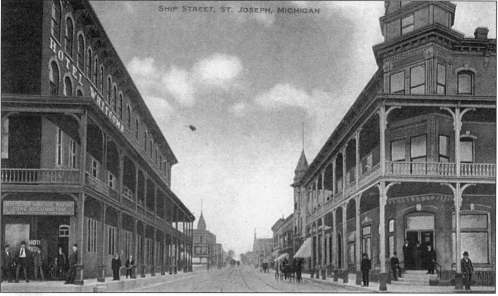

SHIP STREET, ST. JOSEPH, MICHIGAN

The first hotel on the Whitcomb site was the Mansion House. In 1868, Charles Krieger decided to build another hotel to compete with the Lakeview Hotel. He tore down the Mansion House and built the St. Charles Hotel. Sadly, four years after he opened "the biggest and most beautiful (hotel) in the area," it closed in 1872.

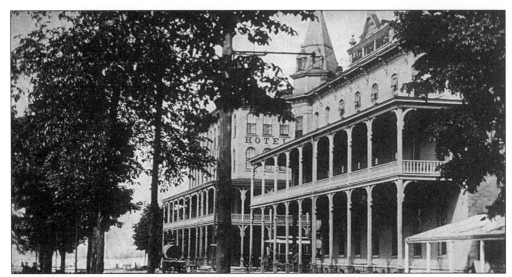

This is a private mailing card which pre-dates 1907. The Lakeview Hotel was built by B.C. Hoyt in 1867, and was originally called the Hoyt House. Lake Boulevard ran in front of the hotels facing Lake Michigan, and Ship Street ran between the two hotels. Today the space occupied by the Lakeview Hotel is a parking lot.

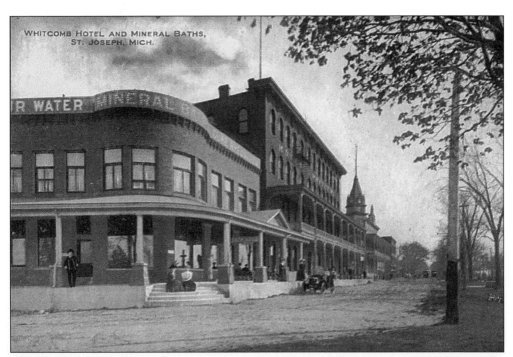

The hotel opened and closed a number of times until Whitcomb purchased it in the late 1890s. He installed the mineral baths that made the hotel famous, but unfortunately went bankrupt six years later. The building was replaced in 1928. It was an active hotel until it closed in 1968. Today, called the Whitcomb Tower, the building serves as a retirement center, continuing to play an active role in the community.

52

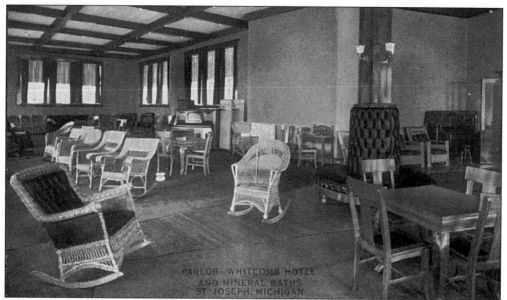

The parlor at the Whitcomb Hotel was probably next to the lobby. It looks like the ceiling is a skylight. What is wonderful is the conglomerate of furniture styles in this room created for entertaining the guests. Notice the wicker chairs and rockers, the card tables, the upright pianos, the velveteen, round dais settee, and the wooden lounge chairs against the wall.

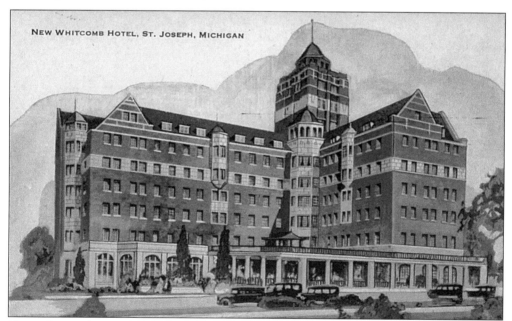

NEW WHITCOMB HOTEL, ST. JOSEPH, MICHIGAN

The Whitcomb Hotel had about 250 rooms and 200 baths, and employed over 200 people. Leon Harris, who took over management of the hotel in 1934, managed its longest prosperity. All the rooms were redecorated, a bar was added in the basement, a solarium with sunlamps was installed, and a banquet room for four hundred people was created out of the patio on the west side.

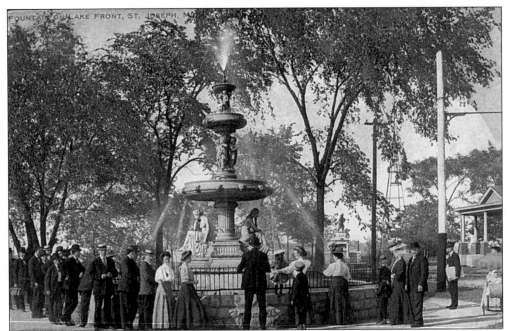

Postmarked 1908, this card shows the popularity of the Maids of the Mist fountain, which was built for the Chicago Exposition from 1873 to 1891. Made in New York City, it originally cost about $5,000. It was moved to St. Joseph in 1892, and placed in front of the Whitcomb Hotel. The current owner, Mr. H.E. Bucklen, purchased the fountain for $500. Maids of the Mist was restored in 1974.

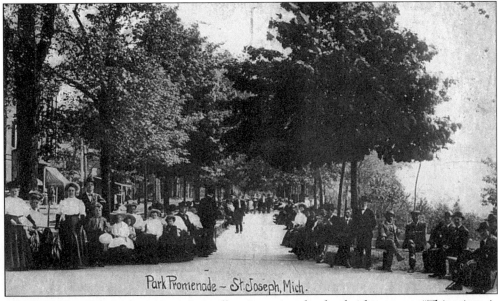

Postmarked 1909 and sent to Rossville, Georgia, the backside states, "This view is showing a portion of our park. Quite a summer resort. Have excellent line of steamers between St. Joseph and Chicago and several railroads. A pretty little city located on a high bluff overlooking Lake Michigan."

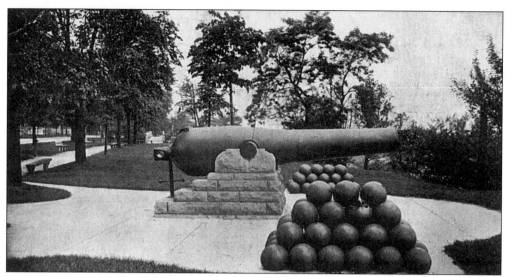

Another private mailing card, this huge Dahlgren cannon was placed in Lake Bluff Park and dedicated by G.A.R. members on July 5, 1897. The cannon was built in 1864 for the *USS Marion*. During the Civil War she helped with southern blockades and chased Confederate privateers along the Atlantic Coast and the Gulf of Mexico. A private individual refinished the cannon in 1989.

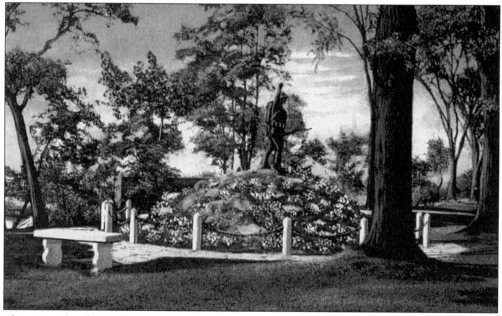

This was the first official replica doughboy statuary erected in Michigan. Holding a grenade in his hand, the statue was dedicated November 11, 1930. "To the memory of all who served in the great World War 1917–1918." Although WW I lasted for four years, the United States was only involved for one year.

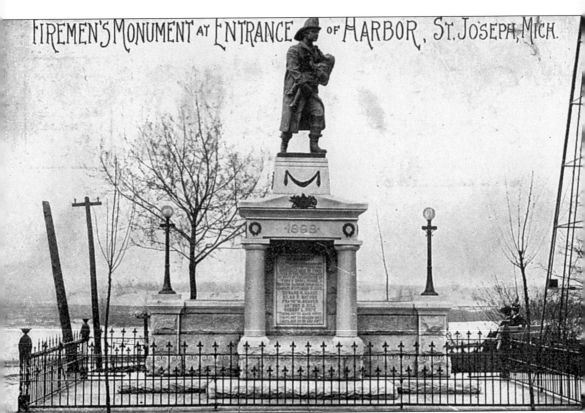

FIREMEN'S MONUMENT AT ENTRANCE OF HARBOR, ST. JOSEPH, MICH.

On the very evening the Yore Opera House in Benton Harbor had staged a benefit performance for the fire department, one of the worst tragedies in Berrien County struck. Evidently, the wooden building became a tremendous blaze, and fearing the fire would spread to nearby buildings, the Benton Harbor firemen called the St. Joseph department for assistance. While in an alley behind the building, the upper wall began to crumble, pouring tons of brick and burning debris on the firemen. Five firemen from St. Joseph and seven from Benton Harbor lost their lives. Two years later, a statue honoring these brave men was dedicated on Labor Day, 1898. It stands on the Bluff overlooking the St. Joseph River and Lake Michigan.

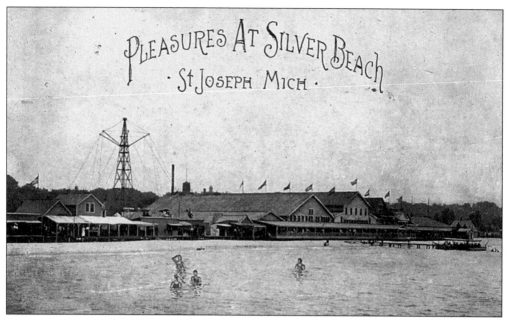

Logan Drake and Louis Wallace formed the Silver Beach Amusement & Realty Company in 1891, which started out as a cabin resort. Later, concession stands were built, and a water slide for children was anchored close to shore. By 1896, an ice cream parlor, souvenir shop, tin-type studio, and a pavilion were constructed.

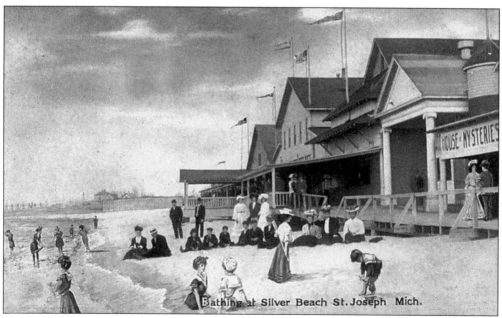

As Silver Beach grew in popularity, Drake & Wallace built a bathhouse with an indoor pool, which used lake water heated by a steam furnace. About 1904, the first roller coaster was installed, the penny arcade and the House of Mysteries, shown here, were added in 1907, the carousel with 44 horses in 1910, the German-made merry-go-round with an organ in 1915, and the airplane ride in 1916.

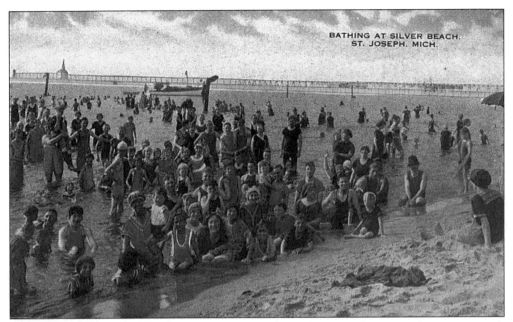

The back of this card, depicting people having fun at Silver Beach, is stamped, "Greetings to our boys in service and in training. Benton Harbor Sunday Schools, Rally Day, October 7, 1917." Silver Beach Amusement Park closed in 1971. Today the beach itself is leased to Berrien County Parks as a public beach.

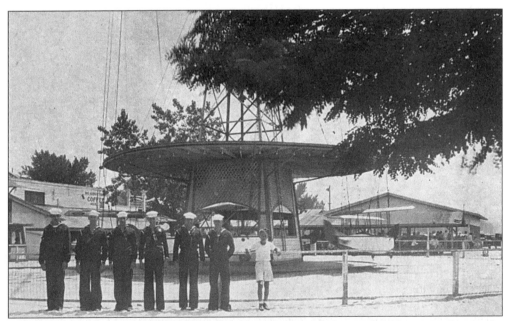

With the Coast Guard station next to the beach and the Naval Training Center in Chicago, Silver Beach was always popular with servicemen. The aeroplane ride was installed about 1916 to honor a flight that took place on Silver Beach in 1898—five years before Orvillle and Wilbur Wright flew at Kitty Hawk. A local inventor managed to glide about 100 yards for eight to ten seconds right over the beach.

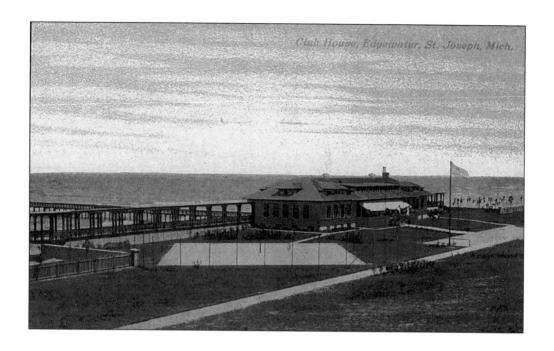

About one-half mile north of the St. Joseph Harbor on the beach in Edgewater, a private club, appropriately named the Edgewater Club, was built. It had docking for the boats and yachts of members and was very exclusive. It burned to the ground about the late 1930s and was never rebuilt.

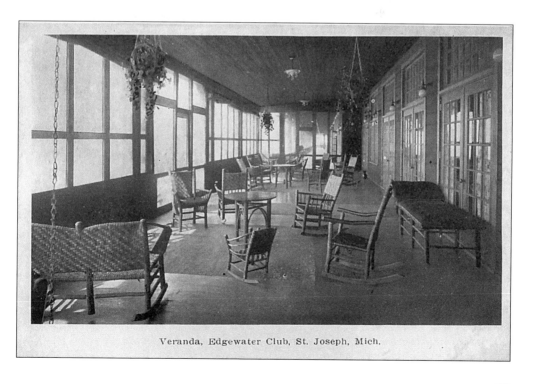

Veranda, Edgewater Club, St. Joseph, Mich.

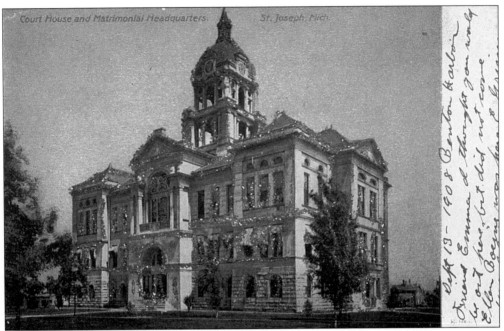

Court House and Matrimonial Headquarters. St. Joseph, Mich.

About the turn of the century, the states of Illinois and Indiana changed their marriage laws to include an application and a waiting period before the ceremony could be performed. Michigan had no waiting period, hence the reason for noting this card, postmarked 1908, showing the St. Joseph Court House and "matrimonial headquarters." Couples could come over by steamship or rail from Chicago, get married, spend time at Silver Beach, and go back home the same day. Another unusual aspect of the card is the "glitter" that has been added by the manufacturer around the roof and floor levels. To postcard collectors, it's called an "add-on card."

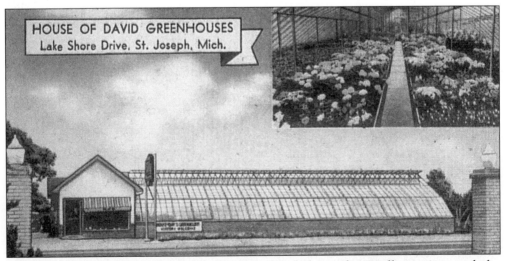

HOUSE OF DAVID GREENHOUSES
Lake Shore Drive, St. Joseph, Mich.

This greenhouse was managed by the Muergenthalens, the Faulkensteins, and the Mantheys—All members of the House of David. It opened before World War I and operated until the late 1960s. . It opened before World War I and operated until the late 1960s.

The St. Joseph Waterworks Building is down below the hill at the south end of Lion's Park Drive at Lion's Park Beach. The building is still used today by the water department.

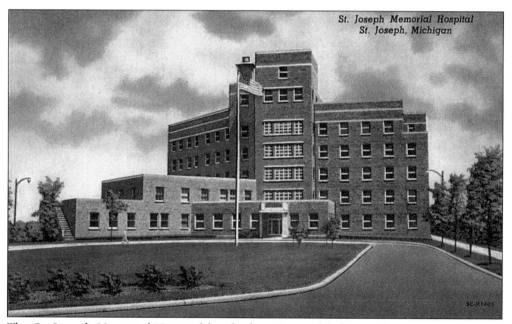

St. Joseph Memorial Hospital
St. Joseph, Michigan

The St. Joseph Memorial Hospital has had sections added over the years, but it's still located on Napier Avenue at the St. Joseph River. Today it is part of the Lakeland Regional Health System and called Lakeland Medical Center.

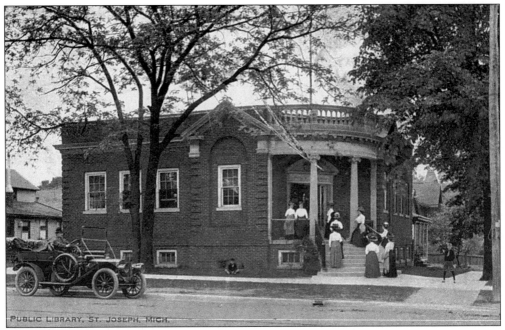

Postmarked 1911, the Carnegie Library was built in 1904 and remained in this building until 1966, when the new library was completed. Located on Main Street, it was built with a gift of $12,500 from the Andrew Carnegie Foundation. Today it serves as the offices of Allegretti Architects.

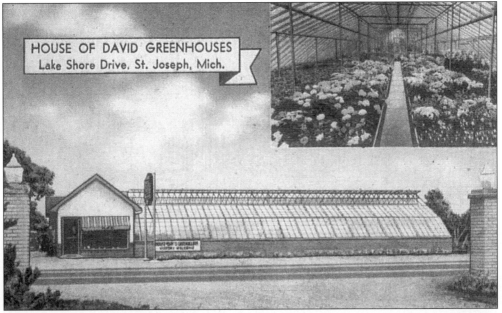

This greenhouse was opened by members of the House of David, the Muergenthalens, the Faulkensteins, and the Mantheys, before World War I, and operated until the late 1960s. They specialized in floral design, cut flowers, and potted plants. No longer owned by the House of David, it still operates as a florist shop.

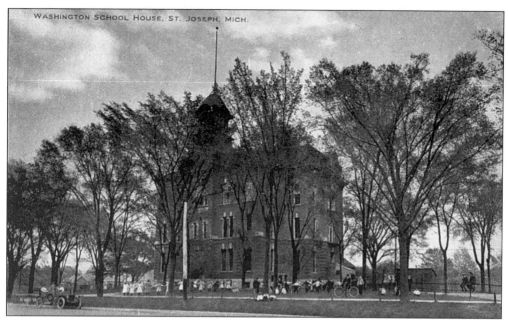

This was an elementary school for many years. Located on Main Street, it is now the Berrien County Administration Building where you'll find, among others, the county clerk's office and the county treasurer's office.

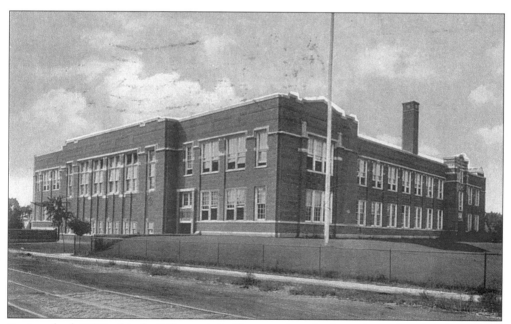

Postmarked 1929, this building originally served as St. Joseph High School until the new one was completed. On Niles Avenue, it served as a junior high for many years before it was demolished.

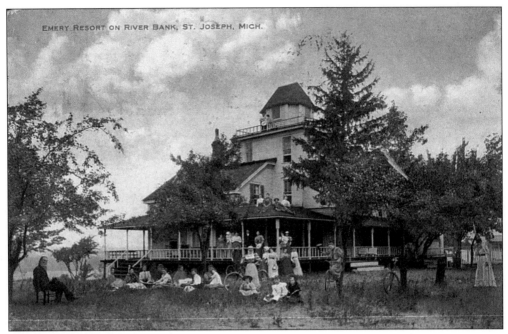

Postmarked 1908, the Emery Resort was built about 1892, by Nelson Cicero Emery on the east side of the St, Joseph River. It was located in St. Joseph Township almost 3 miles from Lake Michigan. He kept the resort open for over 20 years.

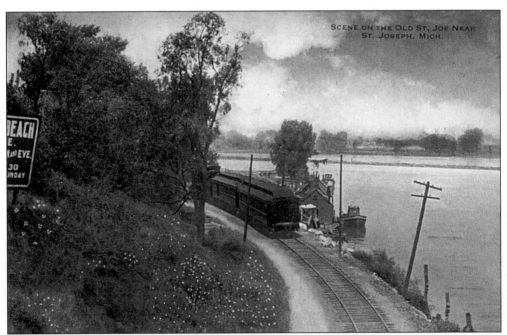

This railroad was probably part of the St. Joseph Valley Railroad, which ran below the Bluff, past Memorial Hospital, and down to Galien. It would haul milk, vegetables, fruit, and eggs to market. It was one of four railroads that crossed the St. Joseph River into Benton Harbor by the House of David Cold Storage Warehouse.

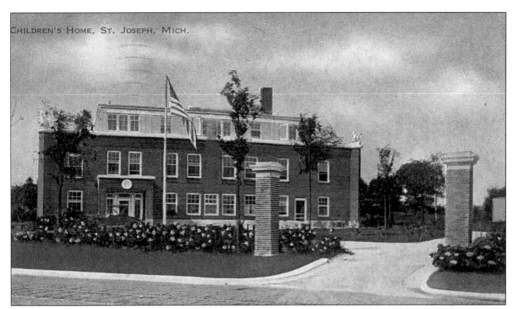

CHILDREN'S HOME, ST. JOSEPH, MICH.

The children's home was called Chapin Hall for Charles Chapin, who contributed $20,000 for is construction. Located on South State Street, it was completed in 1916. The Children's Home Society provided foster care for homeless children. In later years it has housed, among other organizations, LINK, a crisis intervention organization for children and women.

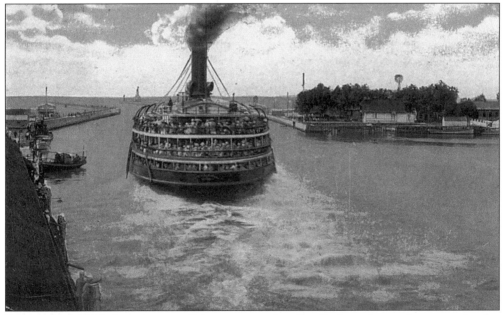

Postmarked 1921, here is one of the steamers leaving St. Joseph, ready to pass by the Coast Guard station and the North Pier lighthouse on its way back to Chicago. On weekdays, the steamers carried fruit and freight to Chicago and transported people back. They carried passengers only on weekends.

Greetings from STEVENSVILLE, MICHIGAN 17.011

This is a generic, stamped greeting card that may or may not be a typical scene of the area. Located just south of St. Joseph, Stevensville was named after Thomas Stevens, a Niles banker who owned a large tract of land in the area and was responsible for laying out the village plat in 1871. It became incorporated as a village in 1893.

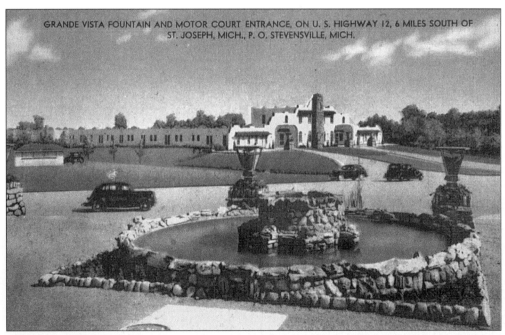

GRANDE VISTA FOUNTAIN AND MOTOR COURT ENTRANCE, ON U. S. HIGHWAY 12, 6 MILES SOUTH OF ST. JOSEPH, MICH., P. O. STEVENSVILLE, MICH.

The Grand Vista was built by the House of David. Their advertisements claimed to combine comfort and convenience of the modern hotel with the intimate friendliness and privacy of the cabin. Each suite had a private bath and lavatory, ultra-modern furniture, innerspring mattresses, and adjoining garages.

The New First Church Camp was one of many such retreats along the coast of Lake Michigan in Berrien County. This camp, near Bridgman, was popular during the 1920s and 1930s. Bridgman was named for George C. Bridgman, one of the founders of the Charlottesville Lumber Company. Bridgman donated the land for a railroad depot and laid out the village about half-a-mile east of Charlottesville in 1870. The two villages were eventually linked together and called Laketon. In 1874, the postmaster initiated the renaming of the community to Bridgman.

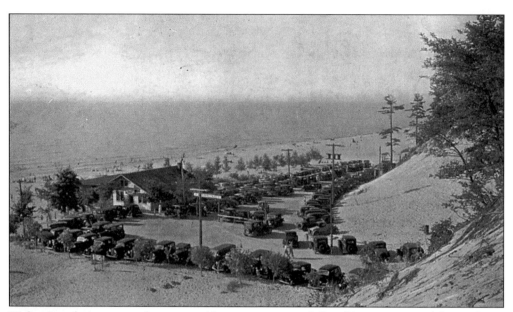

Weko Beach is a popular area with a campground for 65 campsites, 4 log cabins, shower facilities, and a boardwalk. It is located at Bridgman on 900 feet of Lake Michigan beach.

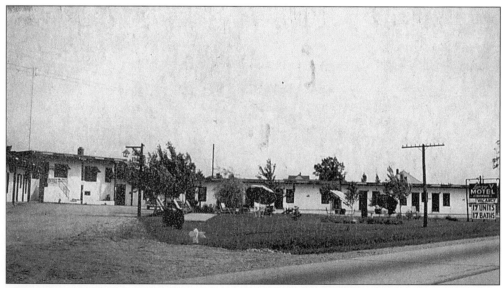

The Lazy V Motel was 12 miles south of Benton Harbor and 2 miles north of Warren Dunes State Park. They advertised, "Private baths, hot water, air cooled in summer, furnace heat in winter. Near golf, swimming, riding, movies, beautiful beaches. Open all year."

Five
TWIN CITY/BENTON HARBOR

Benton Harbor came into existence through the efforts of three men: Sterne Brunson, Charles Hull, and Henry C. Morton. When Spink's Bridge was washed out by a flood in 1858, these men met with businessmen in St. Joseph asking for help to build a bridge and access road across the marsh. No help was offered, so a subscription drive was undertaken among the residents of Benton Township. It was so successful that another drive began to build a mile-long canal allowing ships to come to up the St. Joseph River to the bluffs of Brunson Harbor. No longer would farmers have to take their produce to St. Joseph. In 1870, the Benton Harbor Fruit Market was founded at the city wharf and remained there for many years. In 1865, the village changed its name to Benton Harbor and was incorporated in 1866. In 1868, Leonard J. Merchant began publishing the *Palladium* newspaper. St. Joseph Township, extending across the river, claimed half the village of Benton Harbor, while Benton Township claimed the other half. For a time there was much heated discussion of combining the two villages. Finally in 1891, the state legislature granted two separate charters. Today, they really are "Twin Cities" as they work together to promote the area's current lifestyle and to preserve the past.

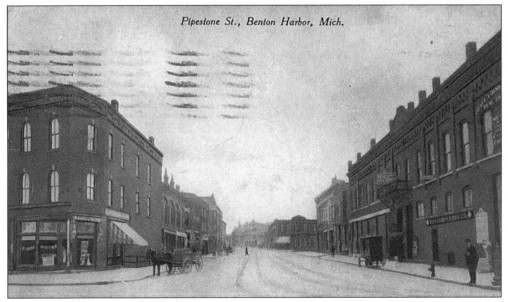

Postmarked 1910, this view is at the intersection of Main and Pipestone Streets. At the right is the Sonner block, built in 1882 by Russell M. Jones and George F. Sonner. Dr. John Bell built the Bell block on the left in 1875. There was a drug store on each corner. The Bell building was demolished in 1989.

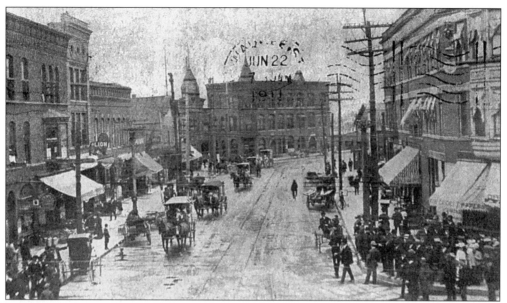

Postmarked 1911, this card captures where Pipestone changes its name to Water Street across from Main. On the right is the Hotel Benton, and in the middle is the G&M Transportation Building that became the post office in 1930. Next to it is the Hinkley Building. J.H. Graham built the building on the left about 1898. For many years it was Enders Department Store. This building was demolished in 1968, an early victim of urban renewal.

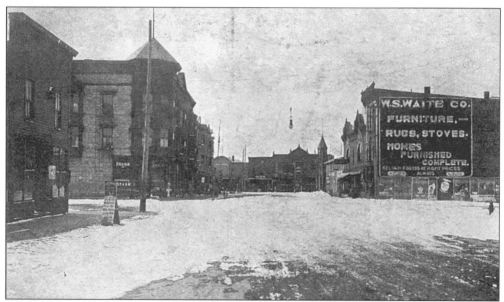

Postmarked 1908, this view is of Territorial and Sixth Streets, looking up to where it dead-ends at Water Street. Myron Hinkley built the Hinkley Building in 1898, seen in the middle of the view. To the right was a hotel owned by Henry Morton and to the left was an office building that was built on the site of the Yore Opera House. It had burned down in 1896.

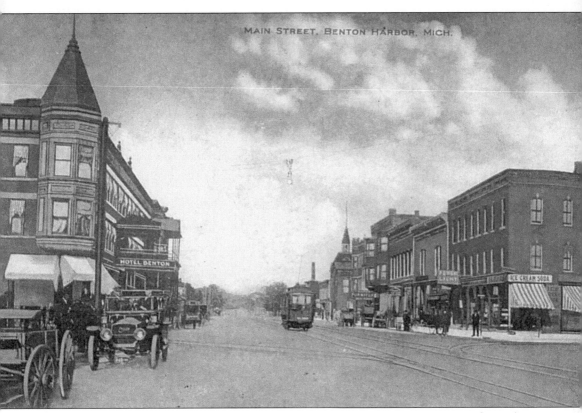

This is a view of Main Street at Pipestone and Water Streets looking east away from the river. At the right is Hotel Benton; on the left is the Bell block. The cupola sits atop the Village Hall. It became the city hall when Benton Harbor became a city in 1891. The building was demolished in 1937, and the location has been a parking lot ever since. The new city hall is on Wall Street. At one time, my grandfather was a conductor for the Twin City Railways, which ran a trolley system from the boat dock in St. Joseph to the House of David until 1935. By that time the bus systems had made the trolley cars obsolete.

This is a real photo card postmarked 1946. It was sent to all the local businesses in Benton Harbor. Remember the Yore Opera House fire? St. Joseph built a monument in 1898 to their firemen who died in the fire. It wasn't until 1946, when these men were responsible for having a monument placed at the fireman's lot in Crystal Springs Cemetery to honor the seven who gave their lives in 1896.

The Premier Bath House was located on the south side of Main Street between Fourth and Fifth Streets. In 1887, a mineral well was discovered near Paw Paw River, and a pipe was laid out to the Premier. After the turn of the century, a new building was constructed that included rooms, the baths, and a café. The Premier was demolished by 1960, and the Transportation Building is now on the site.

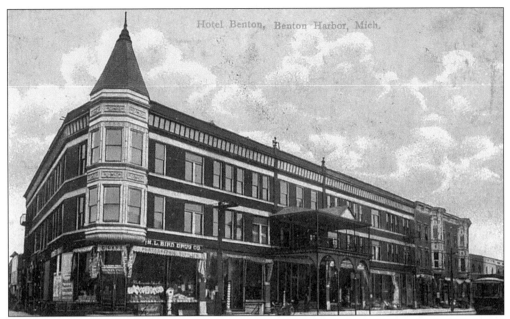

Postmarked 1909, the backside of the card states, "Here for sulphur baths." Edward Brant built Hotel Benton on the corner of Main and Pipestone on the Water Street side. The three-story hotel opened in 1890, with rooms for two hundred guests. It closed in 1932. It was occupied by the Newland Furniture Store in 1944, and destroyed by fire in 1987.

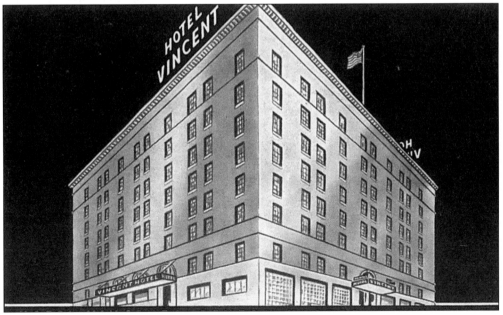

The Hotel Vincent was located at Sixth and Main Streets, with Walter Schroeder as the original president. It had 150 rooms, "all modern, air conditioned." The hotel advertised as being at the "Gateway to Michigan Vacation Land." It also had a cocktail lounge and a coffee shop on the street level.

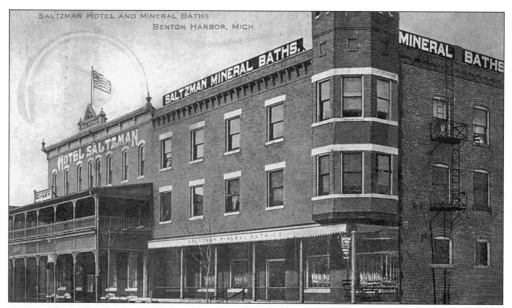

Postmarked 1914, the Saltzman Hotel was built about 1895, at the southeast corner of Fifth and Park Streets. The writer on the backside of the card states, "Stayed at Hotel Duran across the street. Also has mineral baths. They are good for rheumatic and nervous trembles." The building was purchased by the VM Corp. in 1957 and demolished. It is still an empty lot.

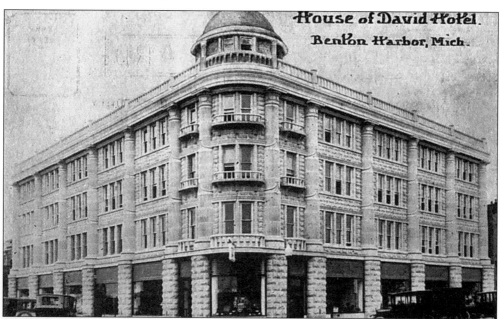

The House of David Hotel was at Colfax Avenue and Wall Street. It was originally designed as one block long and four stories high. When the House of David divided, Mary Purnell was awarded the empty building. She cut the design and the hotel opened in 1931 with a bakery, men's clothing store, and a vegetarian café. In 1932, Robert Griggs became the hotel manager and was there for over 42 years.

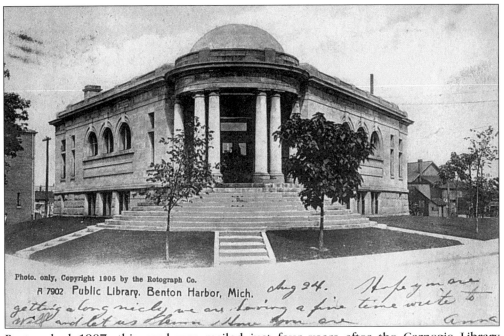

A 7902 Public Library. Benton Harbor, Mich. *aug 24. Hope you are getting along nicely we are having a fine time write to Will and let us know how you are Anna*

Postmarked 1907, this card was mailed just four years after the Carnegie Library building opened as the result of a donation of $20,000 by the Andrew Carnegie Foundation. It served the community until it was demolished in 1968, after the new library was built adjacent to it. The space is now a parking lot.

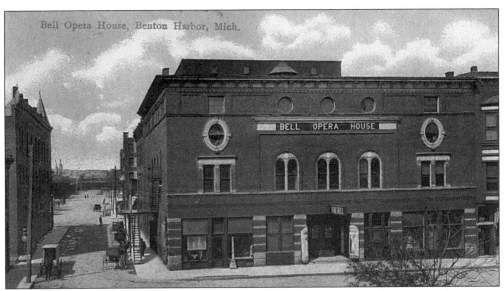

The Bell Opera House was located at Sixth and Wall Streets across from the library. Dr. George Bell built the Opera House in 1900. The 1,000-seat auditorium was the main source of entertainment with vaudeville touring shows, circus acts, concerts, prize fights, and various ceremonies taking place. At the time it burned down, vaudeville was being replaced by movie theaters, and there was no need to rebuild the grand old building.

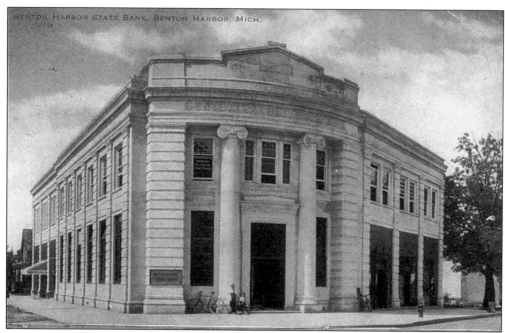

Postmarked 1913, this bank building was built in 1911 at the corner of Wall and Pipestone Streets. The BH State Bank was chartered in 1889. In 1961, it was changed to the Inner-City Bank and in 1994 to the Shoreline Bank. Today, the building houses the Cornerstone Alliance, which is the chamber of commerce for Benton Harbor, St. Joseph, and the surrounding communities.

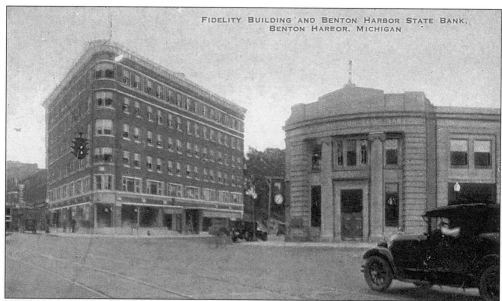

This intersection was known as Five Corners where Pipestone, Wall, and Main Streets met. The BH State Bank building is on the right, and the Fidelity Building is on the left. It was built about 1927, and was basically an office building housing doctors, dentists, and insurance agents. There was the Fidelity Drug Store on the ground floor.

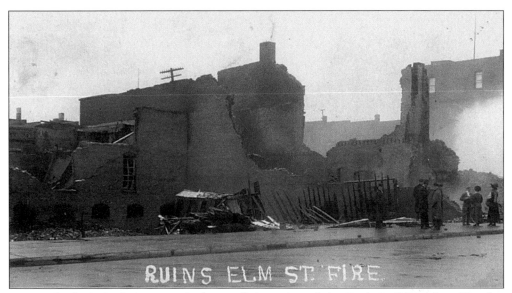

RUINS ELM ST. FIRE

Postmarked 1918, this is a real photo of the ruins of the Peck Building fire. The fire destroyed an entire side of stores on Elm Street that included the *Harold/Palladium* newspaper, Troost Bros. Furniture, Cutler & Downing Hardware and Seed, and Keeter's Appliance and Music Stores. The only building that survived was Pardon's Cigar Store and Billiard Room on the corner of Pipestone and Elm. Today Elm Street is called Wall Street.

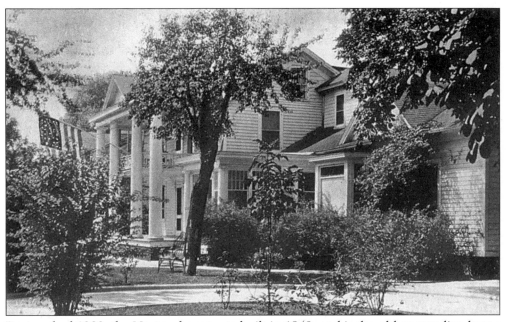

Postmarked 1929, the Morton home was built in 1849, and is the oldest standing home in Benton Harbor. J. Stanley Morton, the third generation to live there, deeded the House to the Benton Harbor-St. Joseph Federation of Women's Clubs to be named in honor of his mother, Josephine Morton Memorial Home. Although the Federation is comprised of 12 member clubs, their general meetings are always free to the public.

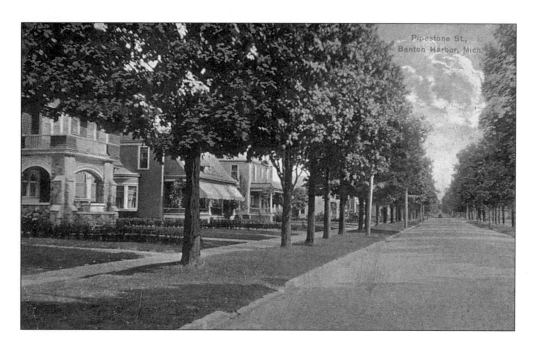

Postmarked 1907 and 1910 respectively, this is the same view on Pipestone Street. The top card is looking south and the bottom card is looking north at the same houses. Considered a depressed area about ten years ago, young couples began moving into the neighborhood and renovating these grand old houses between Division and Britain Streets. Hopefully, the trend will continue to preserve these historic architectural delights!

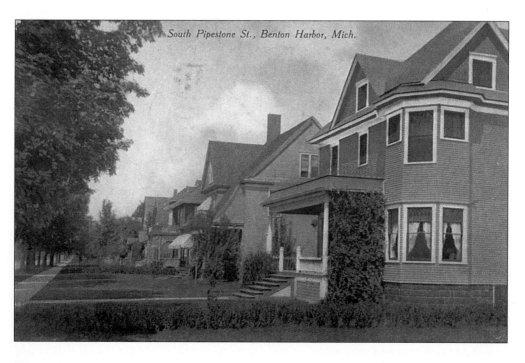

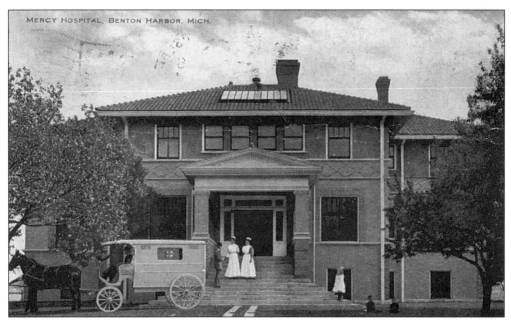

Postmarked 1909, this new Mercy Hospital building was built about 1907 at the corner of Pipestone and Empire Streets. A well-known twin cities physician, Dr. Henry V. Tutton, founded the hospital. He even housed the BH Library in his office for a short time. Empire was built with bricks and remains the same today. The hospital is now part of the Lakeland Regional Health System, but to natives it will always remain Mercy.

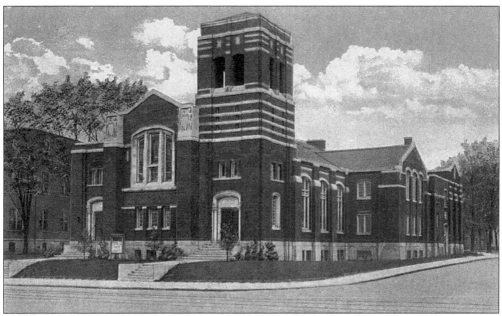

Located on Pipestone Street, three denominations were located within one block of each other. All built at the turn of the century, they all burned and were replaced before 1930. The Methodist Episcopal Peace Temple building was replaced in 1919.

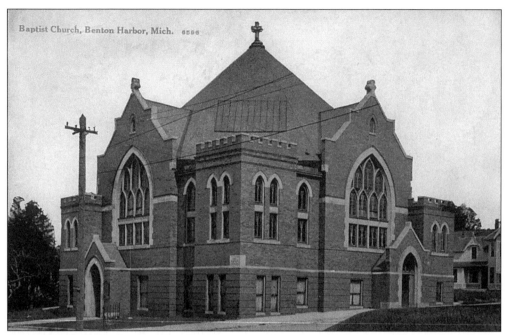

Postmarked 1913, the Baptist church was replaced in 1909, when the earlier church burned down. It is at the location of Dr. Ben Cook (formerly Jefferson Street) Street and Pipestone Street.

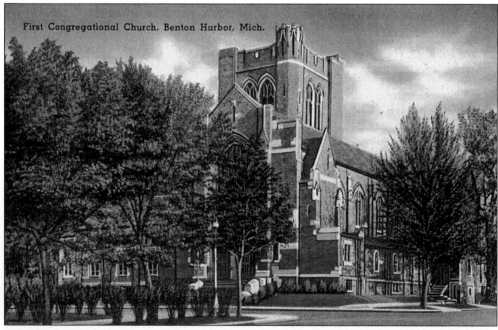

The original First Congregational Church building burned down in 1926, but the new one was completed about 1928. It is at the corner of Bellview and Pipestone Streets. All three churches are still in existence and look the same as they did over 50 years ago.

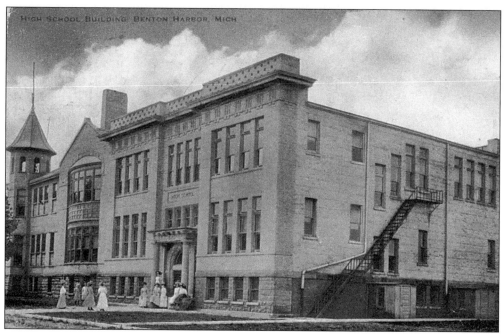

Postmarked 1911, the left part of the building was constructed in 1892, and the rest was added by 1896. My grandmother, Margaret Lucille Smith, was a member of the graduating class from BHHS in 1912. The new high school was located at Broadway and Colby Streets became a junior high school when the new high was built. Years later it was torn town and is now a vacant lot.

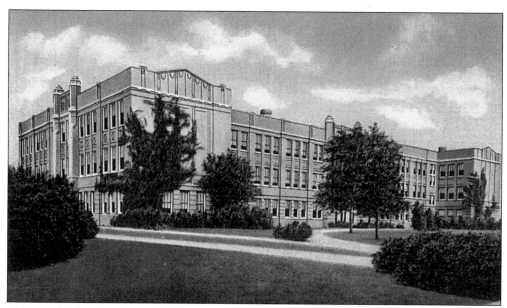

The new high school was built on Colfax at Empire Street between 1921 and 1924. For many years the July Fourth fireworks took place at Filstrup Field. The school looks basically the same today and still serves as Benton Harbor High School.

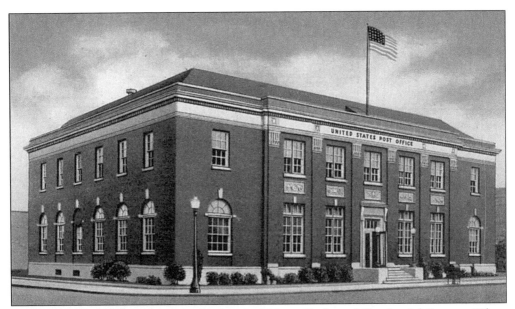

This post office building was built about 1930, at Sixth and Territorial Streets. When the new post office was built on Riverview Drive, this building became the city hall. Today it is a federal building.

The Waterworks Park and Buildings was located on Britain Avenue and Riverview Drive. After it was torn down, a Kmart was built on the site. Today it is the home of Heath Company, an electronics firm.

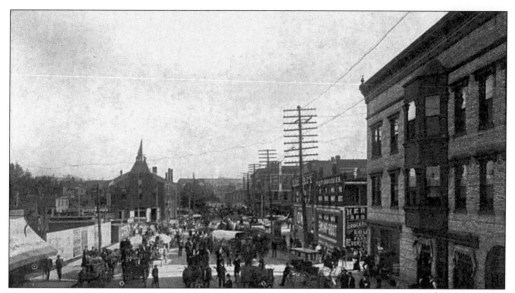

This early card shows the old city hall on Main Street in the left background. The office building that replaced the Yore Opera House on the right is now a vacant lot. Fruit growing has been an important industry in Berrien County since the 1820s, when apple trees were introduced. Peach trees were planted in 1839, and by 1870 Berrien County was number one in the state in peach production.

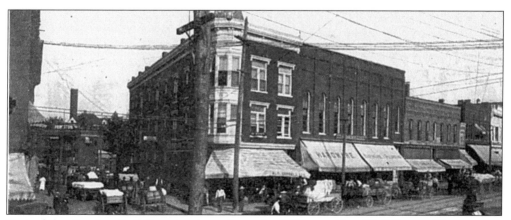

Part of the Conkey Building was torn down in 1928 to widen Wall Street. There was a ballroom on the third floor where activities such as basketball games, dances, and New Year's Eve parties took place. The Naval Reserve even trained there.

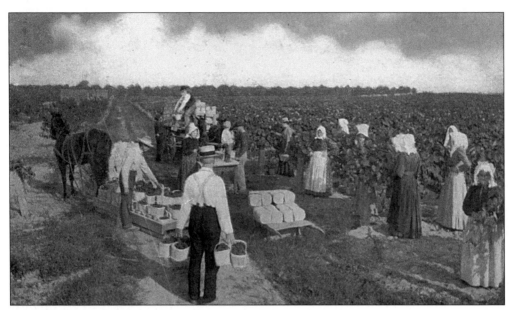

Berrien County is known as the "Heart of the Fruit Belt," because the growing conditions are so favorable that it is the largest non-citrus fruit growing region in the nation. Fruits grown on over five hundred farms include apples, apricots, blackberries, blueberries, cantaloupe, cherries, currants, gooseberries, grapes, melons, nectarines, peaches, pears, plums, raspberries, rhubarb, and strawberries. They also grow over 30 kinds of vegetables. A number of farms are "pick-your-own," and roadside stands can be found throughout the county. The wineries that have their own wine tasting centers include St. Julian Winery of Union Pier, Tabor Hill Winery in Bridgman, and the Heart of the Vineyard Winery in Baroda. An annual "Blossomtime Parade" began in 1923 as a celebration of the blossoms in bloom from the fruit bearing trees and plants and is sponsored by St. Joseph and Benton Harbor.

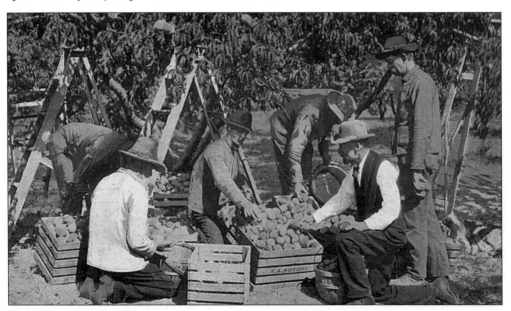

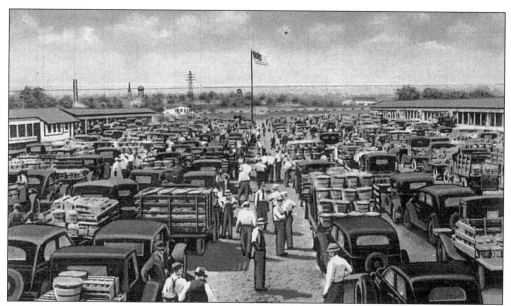

The Benton Harbor Fruit Market was founded on a 34-acre site between Ninth and Twelfth Streets in 1870. It became "the world's largest cash to grower market," where the farmers dealt directly with the fruit brokers and were paid cash for their products. This area was growing so much fruit in the early 1920s, that five to six steamers were making daily hauls to Chicago. Several fruit processing plants are located in Watervliet.

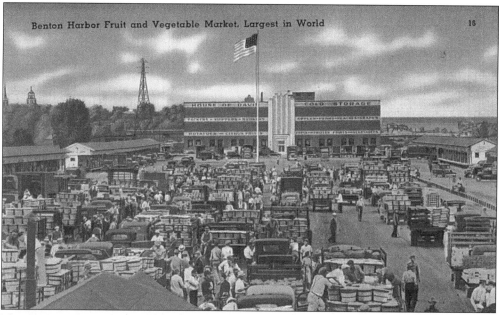

The House of David opened a cold storage plant at one end of the Benton Harbor Fruit Market. H. Thomas Dewhirst was the plant manager, and members of the House of David were the workers. They were the first to freeze many fruit and vegetable products in 1932. They also developed a technique that made it possible to market grape juice in cans. The market moved to Territorial Road in 1967.

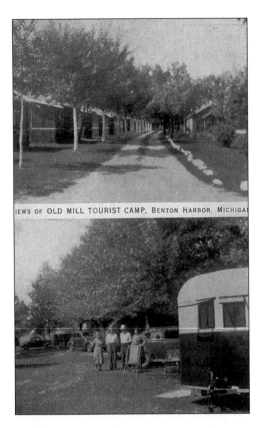

The Old Mill Tourist Camp was located four blocks east of the city limits on U.S. 12 on the road to Coloma. It had 20 cabins and showers available for their trailer park.

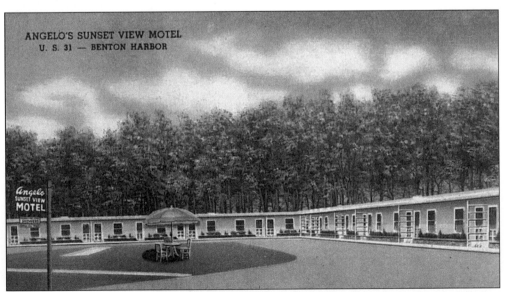

Angelo's was 4 miles north of Benton Harbor. They advertised as an "all new 17 Ultra Modern Tourist Court. Each room has tile showers, panel ray heat, Hollywood Beds, Innerspring mattresses, private beach, owned and operated by Mr. and Mrs. Tony Angelo."

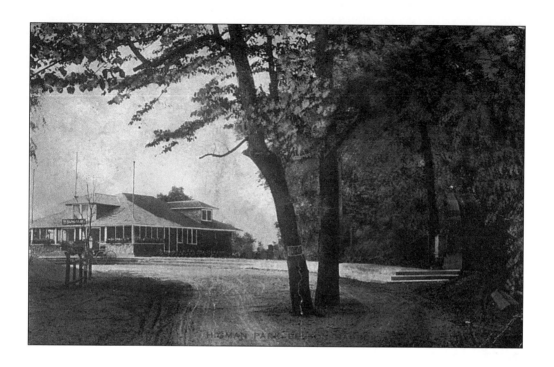

Higman Park was right on Lake Michigan and was little more than a resort area and private beach. It was named after the developer, John Higman, who platted the two hills around 1900. In the early years, this small settlement was known as Higman's Michigan Park.

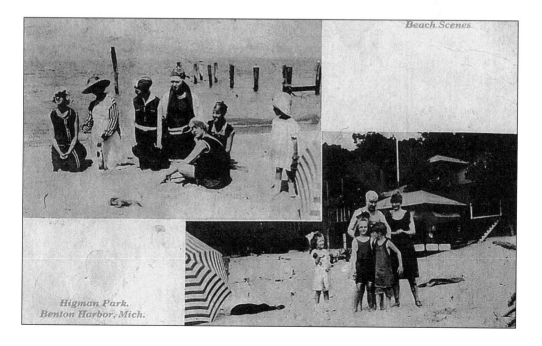

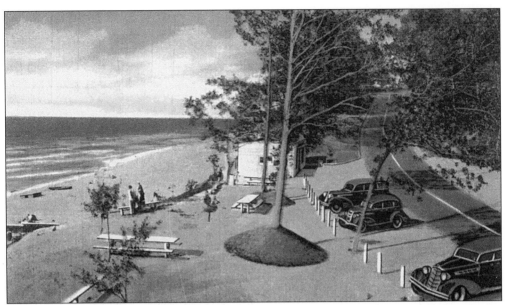

Rocky Gap has always been a public county park. There is a scenic overlook of Lake Michigan with areas for swimming, picnicking, and sunbathing. It is open from April to October.

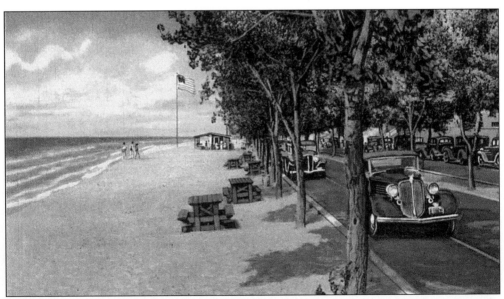

Jean Klock Park is a 90-acre park with a half-mile shoreline on Lake Michigan. There is a children's playground, an observation trail, picnicking facilities, and swimming changing facilities on the beach. The park was named by J.N. Klock in honor of his daughter, Jean.

Here's a real photo postcard of Erman
George Likes, his wife, Nancy Jane Schaub,
and their two youngest children, Gladys
Marie and Nelson Eugene (Bompi). George
was from Indiana, but Nancy Jane was born
in Sodus in 1883. She was the second of six
children born to Frederick Schaub and
Adelaid R. Price, who were lifelong residents
of Berrien County.

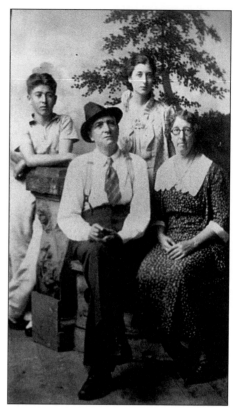

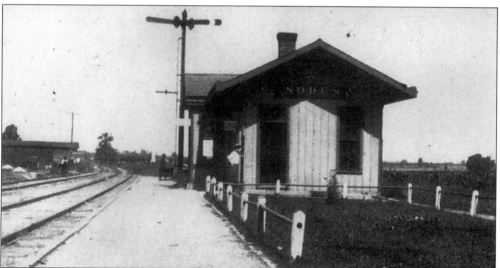

Another real photo postcard, this is the Cincinnati, Wabash, & Michigan Railroad Depot
in 1915. This railroad extended its line from Niles north through Berrien Center, Eau
Claire, and Sodus, to Benton Harbor in 1882. At one time, this line was bringing
excursion trains with up to four thousand passengers to Benton Harbor on summer
weekends to enjoy the beaches and amusement centers near Lake Michigan. Passenger
service ended about 1933.

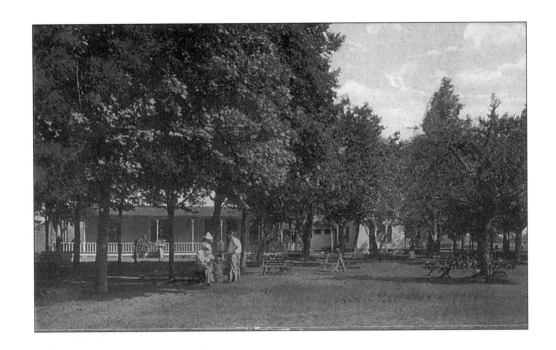

Tabor Farm was established as a summer resort in 1893. It was comprised of 160 acres, with almost every description of fruit grown upon it. The St. Joseph River winds through it, and it is 10 miles from Benton Harbor and St. Joseph. People were allowed to drive their cars right up to the clubhouse door, and the resort sported a nine-hole golf course. Tabor Farm is still in existence today.

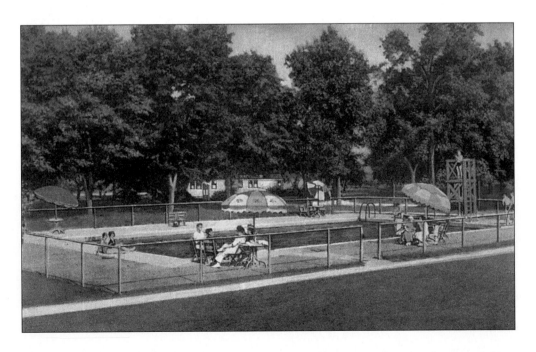

Six
HOUSE OF DAVID

There is no way one could do a study of Berrien County and not give special due credit to the members of the House of David. Forget the scandal that surrounded Benjamin in his declining years and the subsequent division of followers that created the House of David and the City of David. Did they differ from most people in the region? Only in their religious beliefs and unique lifestyle. Did they contribute to the community? Aside from its presence alone, the House of David made a tremendous economical impact on Benton Harbor and Berrien County. Its members treated the sexes equally before women were even given the right to vote in political elections. They were sound businessmen, outstanding athletes, talented musicians, clever inventors, wonderful float builders, and ran one of the most innovative and creative amusement parks in the Midwest. If you've ever been to a bowling alley and watched the automatic pinsetter, eaten a sugar waffle ice cream cone, or drank a can of grape juice, your life has been affected by the House of David. For natives of Benton Harbor, it was much better to witness it all first-hand.

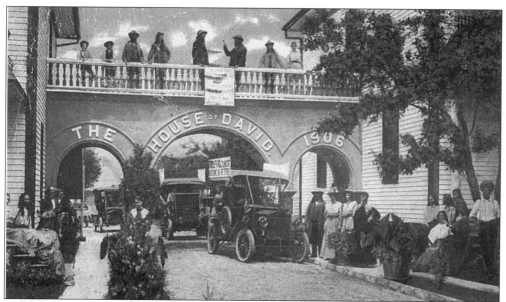

The House of David archway is between the two large residence halls for the Israelites. They were named Bethlehem, built in 1905, and Jerusalem, built in 1906. The arch was to symbolize the joining of the Fifth Church of Israel (the Wroeite) and the Sixth Church of Israel (the Jezreelite) to form the Seventh Church, the Israelite House of David.

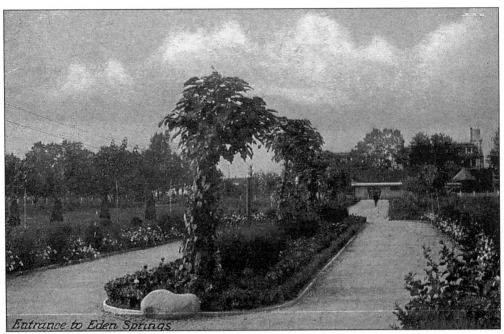

Entrance to Eden Springs

The Eastman family sold a large piece of property to the House of David that was transformed into the Eden Springs Amusement Park in 1908. The park was an immediate success. It was not built in competition with Silver Beach or the other established attractions already there, but it became another "must-see" attraction to the thousands of tourists that came to Berrien County each year. It provided the House of David with a steady financial income and allowed visitors to glimpse the "inside" of the new religious community that was developing in the area.

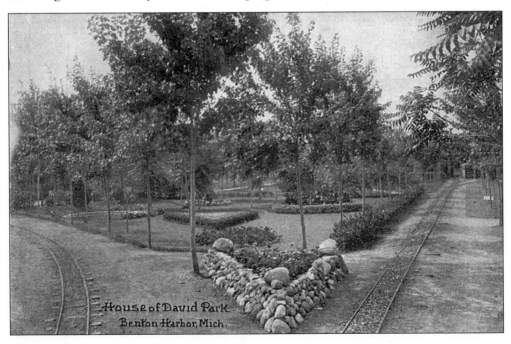

House of David Park
Benton Harbor, Mich.

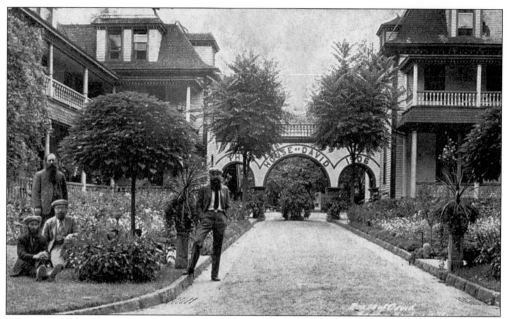

Benjamin Purnell and his wife, Mary, were the founders of the Israelite House of David. Along with five other followers, they came to Benton Harbor in 1903. Adhering to their unique religious beliefs and communal lifestyle, they were able to flourish not only within their immediate community but also throughout the world.

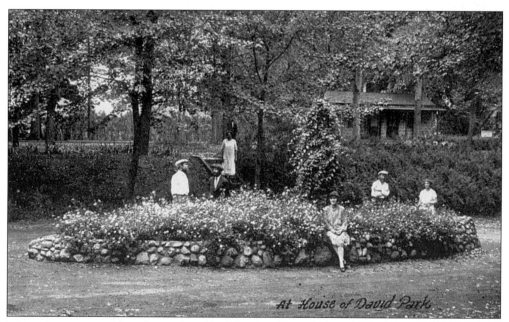

Women were considered equals at the House of David. Many felt that Mary, Benjamin's wife, was also the "Shiloh" or seventh messenger. After Benjamin's death in 1927, it was this belief that split the community in two. After a bitter legal battle, Mary and her followers moved two blocks down Britain Avenue to create the "Israelite House of David as Reorganized by Mary Purnell," better known as "Mary's City of David."

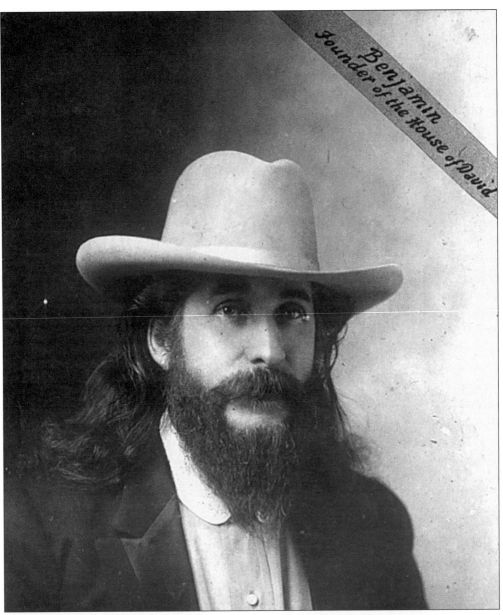

Benjamin Founder of the House of David

Benjamin F. Purnell (1861–1927) was a charismatic leader, an astute businessman, and a scholar and poet, who was also fervently religious. He came from the Christian fundamentalist foothills of Kentucky, traveled the world, and led a religious colony that had followers as far away as Australia. The House of David had controlling interest in the St. Joseph/Benton Harbor streetcar line, and owned lumber mills in northern Michigan. Benjamin himself wrote 17 volumes of doctrinal text, but many do not realize that he also wrote 44 "dialogue plays" and numerous books of poetry and song. His love for baseball created the House of David baseball teams that were internationally famous. His love of music developed House of David bands and orchestras of both sexes. Surely his brilliance will outweigh the scandal that surrounded him before he died.

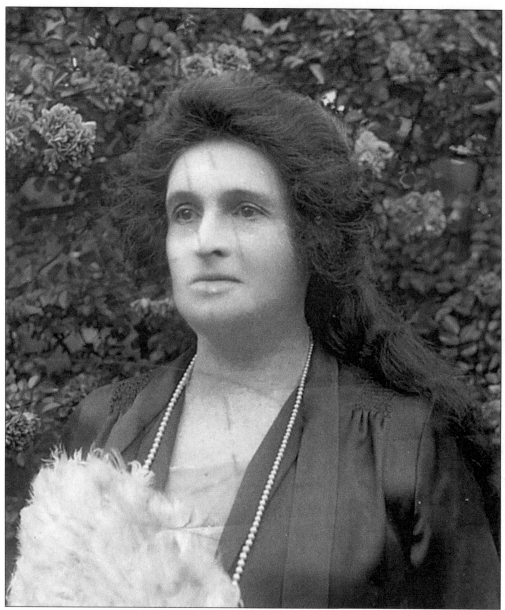

Mary Stallard Purnell (1862–1953) was the perfect mate for Benjamin Purnell. They met in Ohio, married, and had two children. They were traveling preachers for seven years before spending three more years in the Michael Mills colony in Detroit. In 1895, they moved to Fostoria, Ohio. It was in Fostoria that their daughter Hattie tragically died at age 16. Their son, Coy, denounced their way of life. He died at the age of 43. It was Mary who did most of the writing for *Shiloh's Messenger of Wisdom* and later the *Comforter*. She was also the administrator of their office staff. While not as flamboyant as Benjamin, Mary was a deep believer in the doctrines they had developed and was able to keep the City of David solvent for years after the House of David had diminished their assets. By today's standards, Mary was an excellent role model for women's rights and equal opportunity.

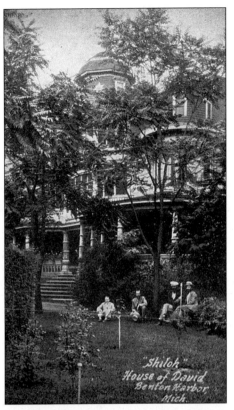

Shiloh residence hall was very elegant and used a "new" construction material—cement blocks—with a special sparkling ingredient called hematite. The inside was beautifully stained and varnished wood. It took almost two years to complete in 1908. This building is still in use and is listed on the State Register of Historic Sites and the National Register of Historic Places.

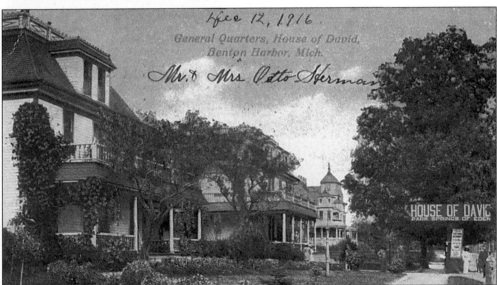

Diamond House used the same hematite-filled cement blocks. Unlike Shiloh, everything in the house was made of cement, including the stairs and railings. Benjamin lived in this hall from 1923 until his death in 1927. It was here in 1926 that state policemen used fire axes to smash in the doors and arrest a frail and sickly Benjamin Purnell on charges of statuary rape.

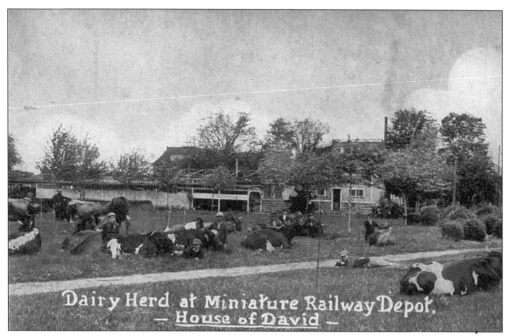

Dairy Herd at Miniature Railway Depot, — House of David —

Besides farming, the House of David raised prize dairy herds of pure-bred Guernsey stock. They were cared for on four different farms: Swamp farm, Stewall farm, Mt. Carmel farm, and Rocky farm.

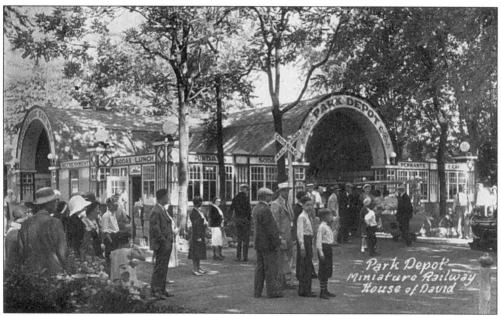

Park Depot Miniature Railway House of David

Other than their waffle ice cream cones, for which they have the patent, the next best memory of the House of David was their miniature train rides. On quiet summer afternoons, you could hear that train whistle over a mile away on Pavone Street, where my grandparents lived. Children and adults seldom went to the park without taking that ride!

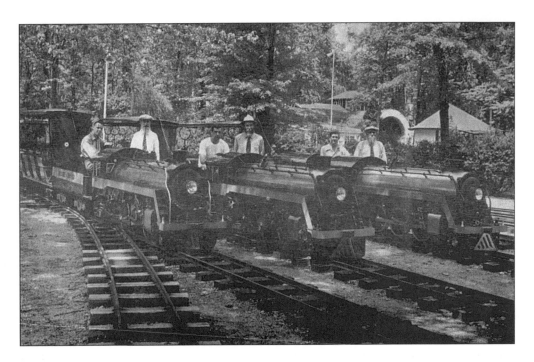

The tracks were laid, and the first small steam engines began taking passengers on their wooden cars in 1908. By the late 1940s, the engines were replaced with larger locomotives. One must always remember that except for the boiler, members of the House of David built the entire train. The train took you throughout the park, over water on trestle bridges, through the woods, by the zoo, and back to the main depot

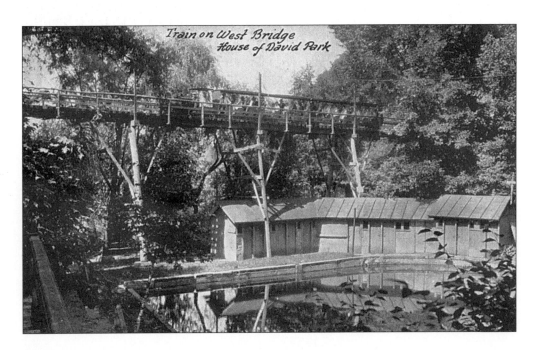

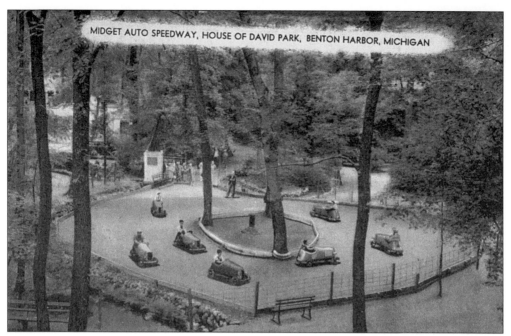

MIDGET AUTO SPEEDWAY, HOUSE OF DAVID PARK, BENTON HARBOR, MICHIGAN

Almost as popular as the trains, every young boy could be an Indianapolis 500 race car driver in one of these cars. Built by the Israelites, each car had a steel frame and body, rubber tires, and gasoline-powered washing machine motors. Remember, Whirlpool's main manufacturing plant in the country was and still is in Benton Harbor. The drivers would actually control the speed of the cars.

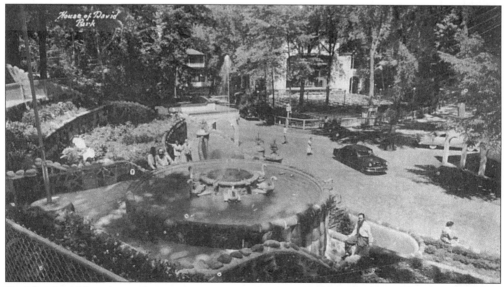

House of David Park

Beside the rides, ice cream, restaurant, and open-air theatre, the park was also filled with lovely quiet spots like this fountain near the entrance. There was also an aviary and the zoo. To accommodate the tourists who wished to stay over, log cabins, made with timber from their own saw mills, were available. Eden Springs was a lovely spot to spend a few days.

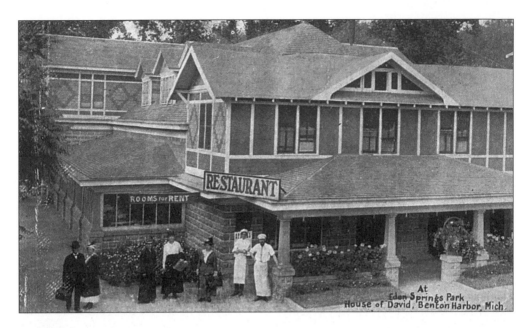

At
Eden Springs Park
House of David, Benton Harbor, Mich.

The second restaurant building in the park was built on the same spot as the original building. The upper floor was a popular hotel for guests. This uniquely vegetarian restaurant opened in 1908. It offered the first vegetarian "mock-meat" of its kind. They also had a very popular cookbook for sale. After the split in 1930, the City of David opened Mary's Vegetarian Restaurant, which operated as a summertime restaurant. They drew a large Jewish and Seventh Day Adventist following. This restaurant closed in 1962. A couple of years ago, Mary's City of David began to serve vegetarian meals again. During summer 2000, they had one meal each month using the original recipes as well as the tables, chairs, dishware, and silver service from the restaurant.

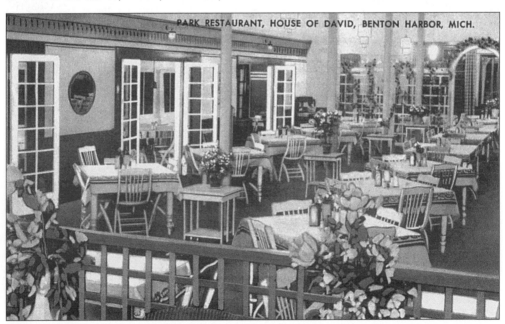

PARK RESTAURANT, HOUSE OF DAVID, BENTON HARBOR, MICH.

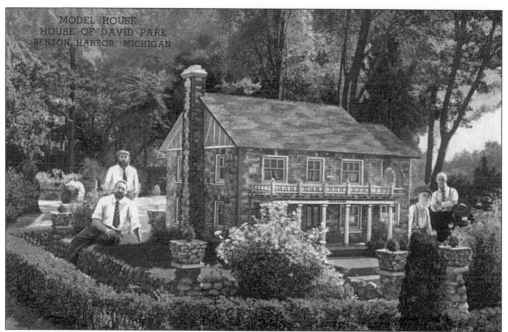

Situated in a garden spot near the zoo and aviary, this model house was built of six thousand separate pieces of granite and marble of different sizes and "many beautiful colors." Each piece was ground by hand to fit the structure. All the stones were gathered from Michigan farms and countryside, as well as the shores of Lake Michigan.

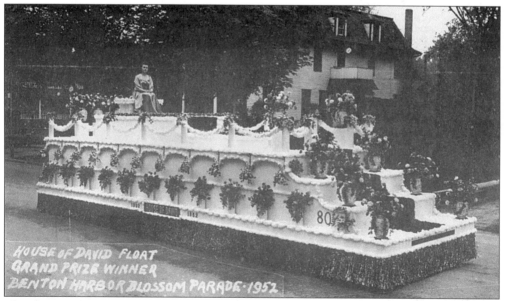

The House of David was an enthusiastic participant in the Blossomtime Parade and was famous for their spectacular floats. One story goes that over the years they won the grand prize so often that the parade organizers asked them to take for a few year hiatus in order for someone else to win. Here is their award-winning float in 1952.

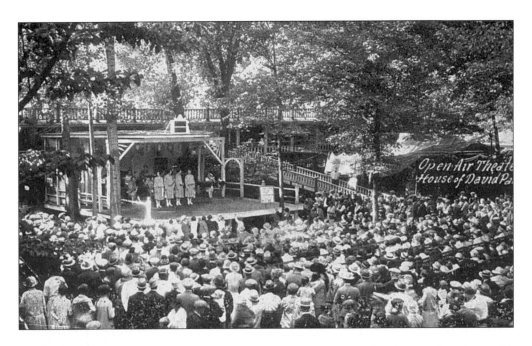

Shortly after Benjamin Purnell died in 1927, the House divided, and Judge H.T. Dewhirst took over control of the House of David. One of his first projects was to update the park by tearing down the small open-air theater and replacing it with the huge amphitheater seen below. Not only did the House of David bands perform here, they held amateur contests as well. There was even a dance floor next to the stage. Dewhirst also installed a bowling alley and penny arcade behind the stage. The House of David holds the patent for the automatic pinsetter for bowling alleys.

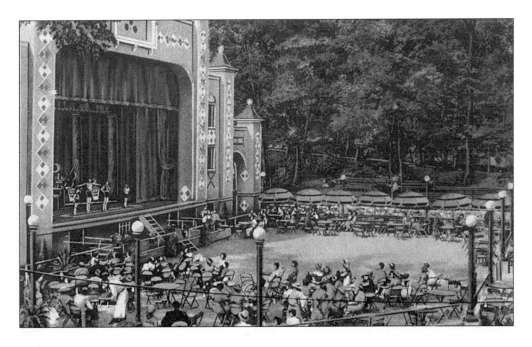

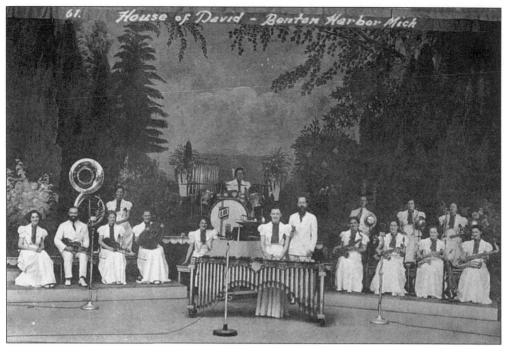

Benjamin Purnell could not read music, but he wrote songs and encouraged musical development within the colony. They had boys' and men's bands, a girls' band, a ladies' orchestra, and a jazz band.

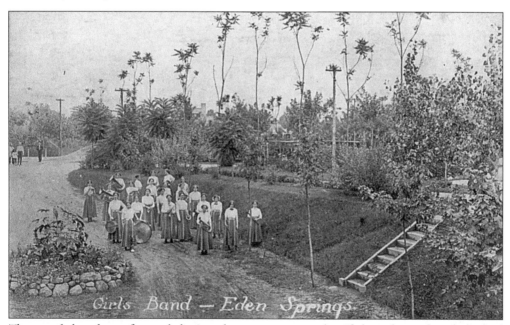

The youth bands performed during the summer months. If they showed real musical talent, they would graduate to the adult bands and orchestra. All the costumes for each band was made by Israelite tailors, in a large tailors shop in the colony where costumes were made and stored.

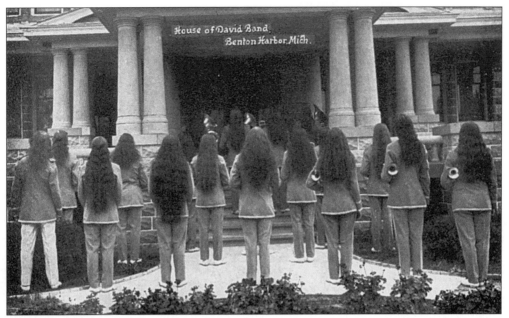

The most popular group was the "Syncopep Serenaders," who advertised themselves as the "Shaveless Shieks of Syncopation." They were headliners throughout the 1920s, and filled theaters wherever they went. They would begin their performance with their backs to the audience, so that all that could be seen was their long hair. It wasn't until they turned around that one could see the beards and mustaches. They literally brought the house down with their virtuoso jazz performances.

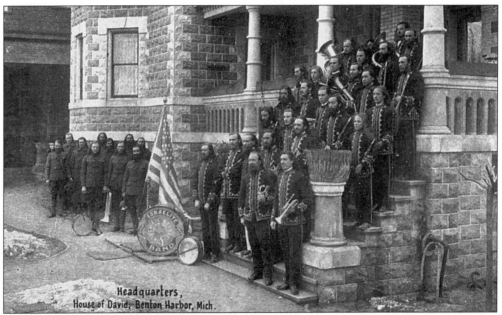

Many of these bands toured throughout the United States, giving performances and playing in parades. John Phillip Sousa supposedly directed the men's band in San Francisco during a performance there.

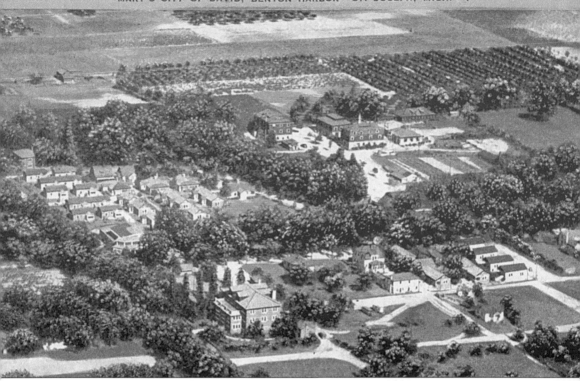

When the division of the House of David occurred in 1930, Mary walked two blocks down the street and began all over again in a tent. They looked over their assets and felt, after building a dormitory for her followers, that getting the House of David hotel up and running should be the number one priority. The hotel had been sitting empty for seven years, but was completed within a year and stayed open from 1931 to 1975. They next opened the vegetarian restaurant on Britain Avenue as a summertime business, and built tourist cottages on the property, catering to the Jewish community at a time when they were still being shown prejudice. In the center of the left side of the card, one can see the round amphitheater where the museum/gift shop has recently opened. It is worth your time to see the excellent displays that have been created.

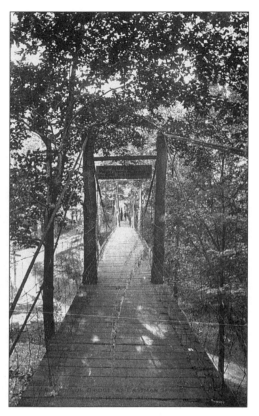

In 1945, the City of David purchased the 54 acres of Eastman Springs, an established resort in southwestern Michigan since the late 1890s. Eastman also had 27 natural springs from which he sold bottled water to fashionable hotels and restaurants in Chicago. Today, one can tour the nature trails of the woodland acres of the Eastman Estate. They have rediscovered fifteen of the original springs, and six have been cleaned and tested safe for good quality drinking water.

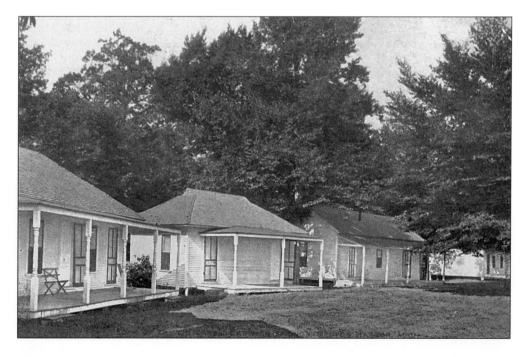

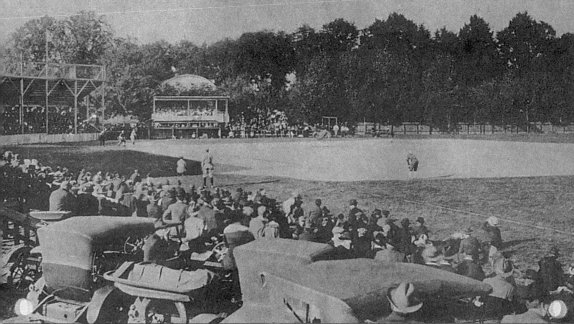

Israelite House of David
Baseball Grounds

House of David v. Chicago Union Giants

No one is exactly sure when baseball began at the House of David, but some believe it grew out of developing organized activities for the youth after school and in the summertime. Benjamin asked Francis Thorpe, the colony's secretary, to organize a House of David team. By the 1920s, they had a traveling team, a home team, a boy's team, and a girl's team, which was never defeated. Even when the House was divided in 1930, they maintained separated teams. Mary's City of David team toured until the mid-1950s, while the House of David team ceased after World War II. The City of David's team was the first to ever hire a female professional athlete. Jackie Mitchell, a pitcher, played in the game that defeated the Cardinals, 8 to 6, in 1933.

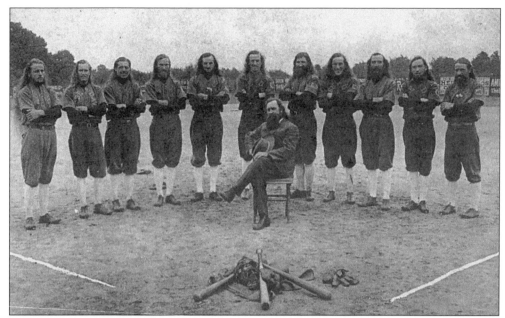

This 1919 team was one of the most popular teams. All of the players were true members. Paul Mooney, fifth from the left, was a pitcher for the traveling "A" or all-star team. His parents were part of the original seven who began the Israelite House of David in Benton Harbor. At the far right is J.L. "Doc" Tally. He was another pitcher and also considered the "Babe Ruth of the colony."

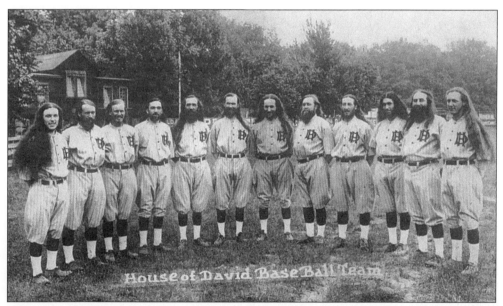

This is the 1928 team that won 110 games and tied 3 out of 165 games that year. They traveled 23,000 miles by automobile. They played against the Negro League teams and traveled with Satchel Paige and the Monarchs. They also played against the Chicago Union Giants and the Atlanta Black Crackers. They were one of the first teams to play "under the lights" and brought all their own lighting equipment.

Seven
NORTH BERRIEN

Most of the early settlers of North Berrien were either from Canada or of German descent. They came to New York City and then traveled to Buffalo, NY. The next stage of the trip took them across Lake Erie to Detroit, MI. Here they could cross Lake Huron and Lake Michigan or go by marked trails to western Michigan. By 1836, Territorial Road was established as a highway linking Detroit and Chicago. It went right through Keeler and Bainbridge, on to Benton Harbor, and finally St. Joseph. With very limited tools, usually nothing more than a saw, a hammer, and a simple plow, these early settlers discovered that farming was the best lifestyle for them in this area. After clearing the land and building their log cabins, they began planting crops. When fruit was brought to the area, the farmers in North Berrien became the largest peach, pear, and apple growers in the region. There are fewer towns and villages in this part of Berrien County. In fact, Bainbridge Township has only two small trading centers. Most of the land is still farmland and many of the farmhouses have been in the same family for over 100 years. For recreation one went to Paw Paw Lake.

Here is a real photo of Main Street in Watervliet. Next to the Gulf Station is the Carmody Bros. Drug Store, and next to the hardware store is the Watervliet State Bank. On the left is the Smith Building, which was built about 1914. Today it houses a bakery shop and the post office.

This overview of Watervliet was taken from the water tower seen in the card below. All you see behind the Catholic church and its parsonage are private homes. Watervliet was originally called Waterford. It was incorporated as a village in 1891, and as a city in 1924.

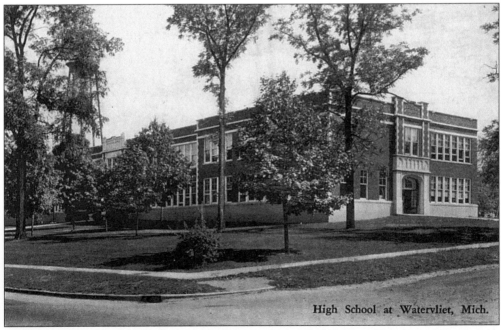

The Watervliet High School was built about 1923 at the corner of M140 and St. Joseph Street. It cost $250,000 to build. In 1967, a new high school was built on the Red Arrow Highway on the east side of the city, at a cost of $2 million.

Here is a view of the south end of the Watervliet Paper Mill. After tearing down the old mill, Sims & Dudley Paper Co. built a paper mill on the same site in 1893. F.F. Smith was in charge of the construction and stayed on as the millwright until 1901. They sold it to the American Writing Paper Co. in 1899, and it became the Watervliet Paper Mill in 1910.

The Paw Paw River was named either for the yellowish, banana-like fruit or the paw paw trees that could be found along the riverbanks. The river ran south of the lake above Coloma and Watervliet.

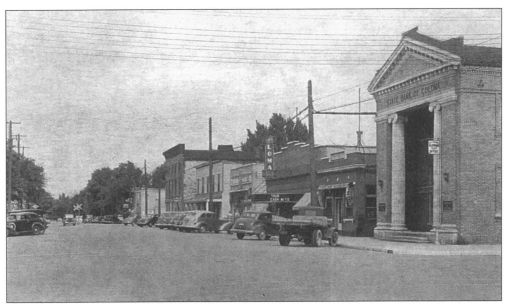

The main street in Coloma is actually called Paw Paw Street. The Loma Theater burned down, next to it was a grocery store, and two buildings down from that was the Opera House that had a lumber company on the lower floor. The upper floor was used for community activities that accommodated any group. The last building you see before the railroad tracks was Dr. Baker's building.

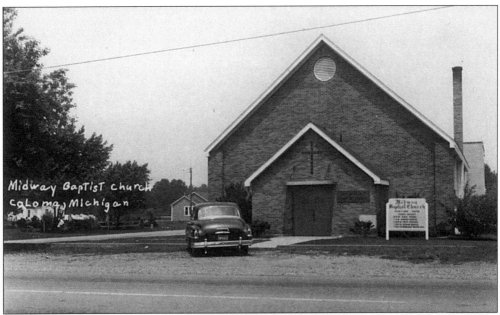

This is a real photo of the Midway Baptist Church on the Red Arrow Highway between Coloma and Watervliet. The Red Arrow Highway was known as US 12, and was part of the original stagecoach route between Detroit and St. Joseph. They have made a number of additions to the original building, but the church is still in existence on this site.

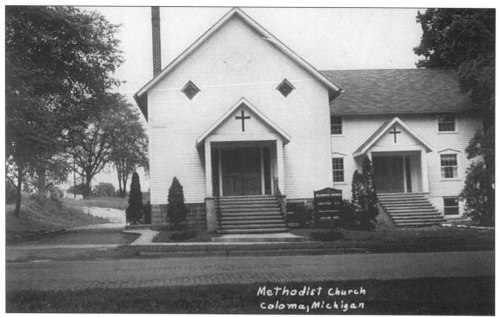

Methodist Church
Coloma, Michigan

This is a real photo card of the Methodist church in Coloma. It is still at the same site on Church Street. The structure has been added to, but one can still recognize this part of the building.

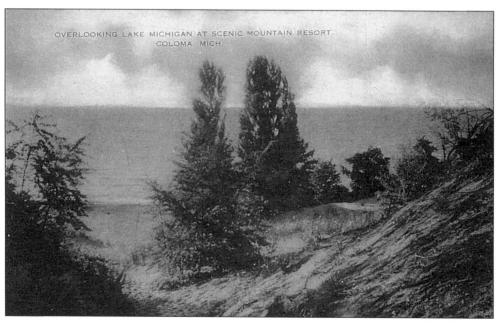

OVERLOOKING LAKE MICHIGAN AT SCENIC MOUNTAIN RESORT
COLOMA, MICH.

Postmarked 1937, this is an example of how humorous a card can be to the local residents. You can see Coloma stamped on the card, but picture this: Lake Michigan is at least 4 or 5 miles from Coloma, and there is no mistaking these sand dunes for a mountain. Sometimes publishers weren't too careful about finding general scenic cards that could be from a specific area.

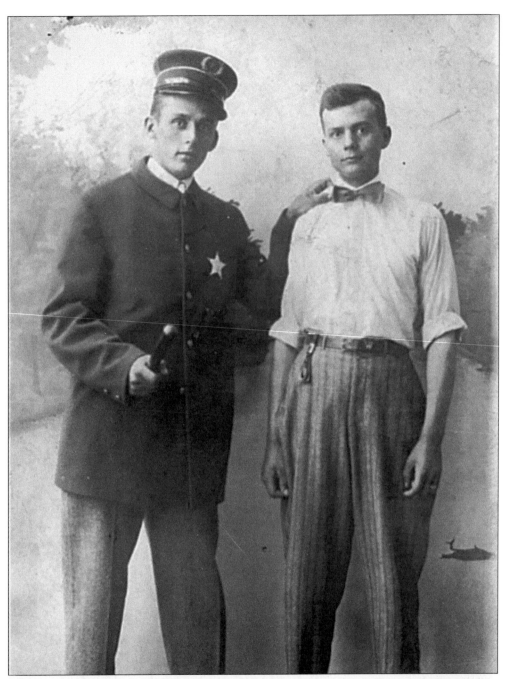

Here are two natives of Bainbridge Township enjoying the photo arcade at Silver Beach. On the right is Walter A. Koerber, uncle to Frank A. Arent on the left, and only nine days older. Walter was the thirteenth child of Gustave Koerber and Catherine DeTemple, born September 14, 1891. Frank was the first child of Frank C. Arent and Mary C. Koerber, born September 23, 1891. Mary was the second child of Gustave and Catherine, born November 3, 1869. Walter and Frank were lifelong friends and died within six months of each other.

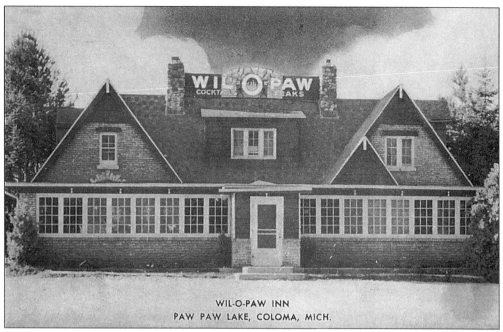

WIL-O-PAW INN
PAW PAW LAKE, COLOMA, MICH.

On the southwestern tip of Paw Paw Lake is the Wil-O-Paw Station and Inn. It was open all year, and the restaurant served steak, chicken, and seafood. They also advertised "in the winter months we have a cozy fireplace waiting for you to enjoy."

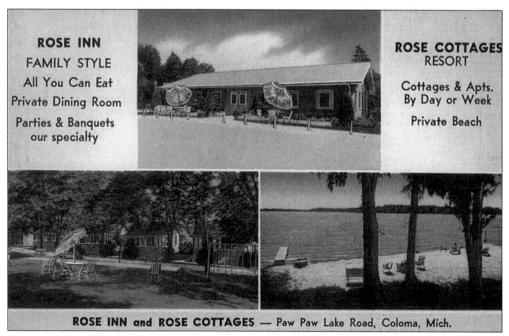

ROSE INN
FAMILY STYLE
All You Can Eat
Private Dining Room
Parties & Banquets
our specialty

ROSE COTTAGES
RESORT
Cottages & Apts.
By Day or Week
Private Beach

ROSE INN and ROSE COTTAGES — Paw Paw Lake Road, Coloma, Mich.

Rose Inn and Cottages were across the tracks from the Wil-O-Paw. The back of the card advertised, "We hope to see you again, your home is our only competition. Private parties are our specialty." Their cottages were seasonal, from May 1st to October 1st by the day or by the week.

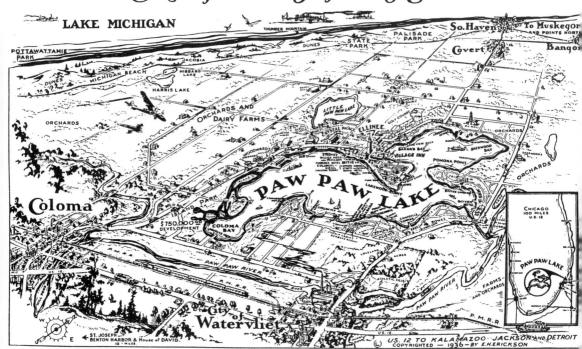

Paw Paw Lake
Michigan's most Popular Resort

SOUTHERN MICHIGAN'S LARGEST INLAND LAKE

Used by permission of Ferne Erickson Betz, this 1936 free-hand drawing of Paw Paw Lake and its surroundings shows what the whole area looked like when there were still interurban trains making daily runs to the lake. By starting at Coloma Bay and going north towards Little Paw Paw Lake and back around past Watervliet, one will be able to get an idea of where the following images are on the lake.

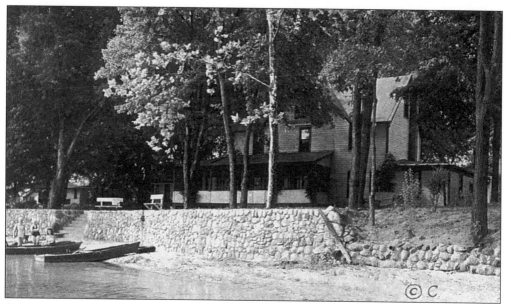

Our next stop is at Brown View Lodge. Still open in the 1960s, they offered a private beach, modern conveniences, and a "sun pier."

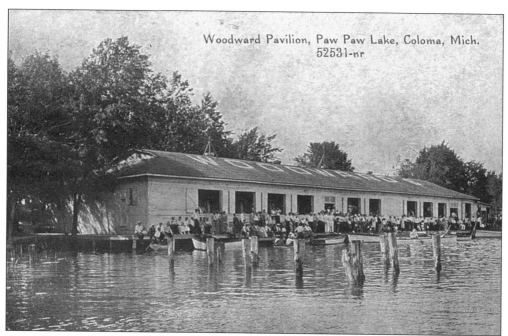

A.H. Woodward originally built Woodward Pavilion in 1899. They held nightly dances, had bowling, billiard and pool tables, and refreshments of all kinds. Many of the various types of boat races would start from this pavilion.

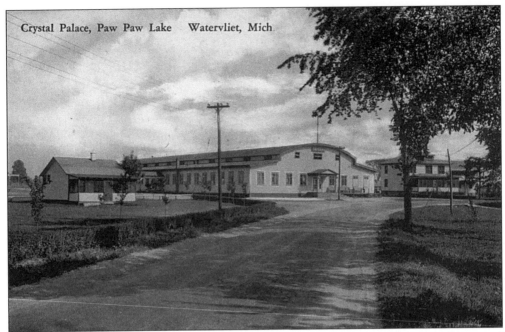

Crystal Palace, Paw Paw Lake Watervliet, Mich.

Dlouhy built the Crystal Palace in 1925. It was known as the "Grand Ballroom of Southwest Michigan." It was a standard place for all the big bands to perform either coming into or leaving Chicago. Every big name in the business played at the Crystal, including Guy Lombardo, Stan Kenton, Lawrence Welk, and Louis Armstrong. Dlouhy also had a baseball team that played against the House of David for the Southwestern Michigan championship.

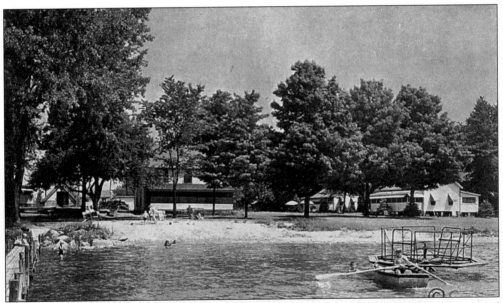

Strong's was one of the larger establishments on the lake. Run by George Strong and his sons, there was a boat landing, cottages, and, at one time, a station stop for the interurban trains. There are now condos in this area.

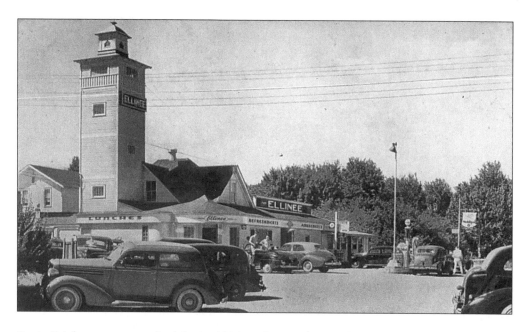

Ernie Erickson came to the lake in 1909 and started a small store. He even started a bus service to the lake until the early 1920s. The tower was added as an attraction for tourists to climb to the top and see the eagle that was kept there. It was a lunchroom, bowling alley, liquor store, and dance hall. In the late 1920s, he constructed a building across the street as a place for artists to mix art studies with vacations, and put on local exhibitions. Later it became a well-known playhouse. In 1971, it became a nightclub. Today the Elinee Resort and Playhouse has been torn down, and it is an empty lot.

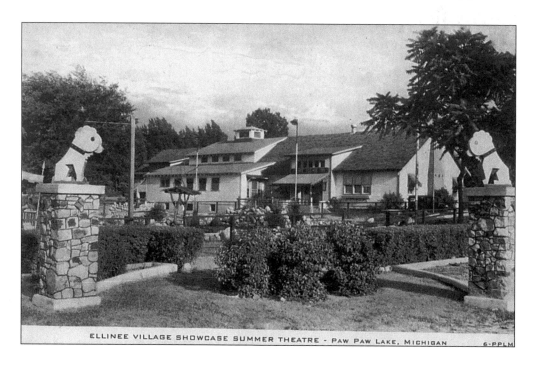

ELLINEE VILLAGE SHOWCASE SUMMER THEATRE - PAW PAW LAKE, MICHIGAN 6-PPLM

119

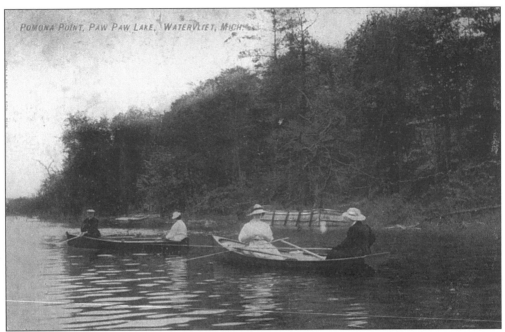

Pomona Point was a popular inlet for many a year and until 1922, much of the property around it was owned by Sebastian Smith. Mr. and Mrs. A.F. Botto bought the farm and buildings and subdivided it into 260 lots. They changed the name of the area to Fairview.

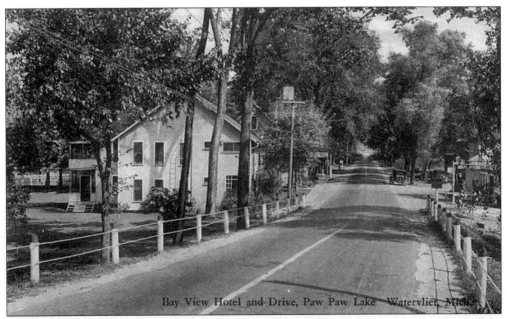

The Bay View Hotel was part of Pomona Point and close to Smith's Landing. They advertised for "bathing, dancing, horseback riding, moonlight boating, and good home cooking." When Ernest Hemingway was 17 years old, his parents supposedly have spent the night at the Bay View Hotel. It is no longer there.

Fairview Beach, West, Paw Paw Lake Watervliet, Mich.

Here is a vista of Fairview Beach after Smith's property and the Bay View Hotel had been sold. While allowing for more people to build homes and cottages by the lake, it also began to take away from the family oriented resort atmosphere that had been a part of Paw Paw Lake for so many years.

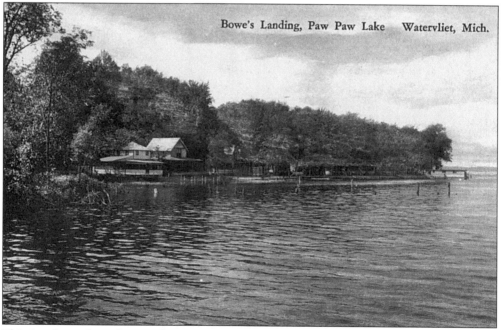

Bowe's Landing, Paw Paw Lake Watervliet, Mich.

This is where the tributary flows out of Paw Paw Lake into the Paw Paw River, known for many years as Outlet Bay. It is more commonly known as Bowe's Landing. This view shows his farmhouse right on the water.

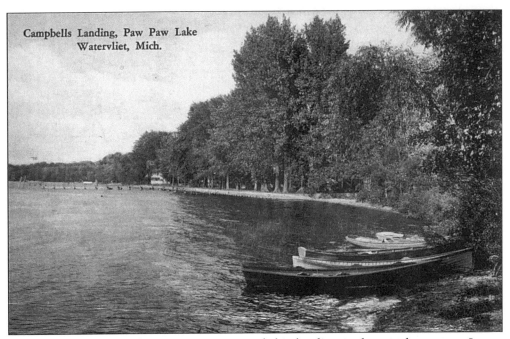

Campbells Landing, Paw Paw Lake
Watervliet, Mich.

Campbell owned the shore property around this landing and several cottages. It was not unusual for the summer tourists to identify where they stayed on the lake by the "landing" or "point" that was near their resort.

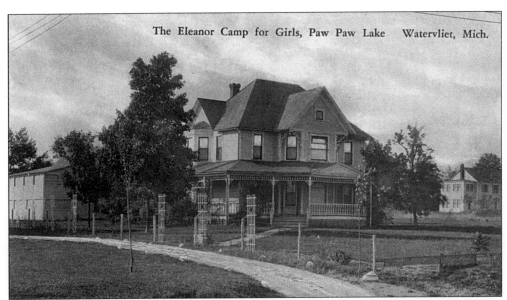

The Eleanor Camp for Girls, Paw Paw Lake Watervliet, Mich.

This was a high-class private girl's camp on Campbell's Landing. They advertised throughout the Midwest as having organized activities for young girls during the summer months. Activities included swimming, horseback riding, canoeing, and crafts.

There were seldom less than 50 hotels, cottages, tourist courts, and inns around the 1,200-acre lake. The Wabana Hotel was one of four hotels right on Forest Beach.

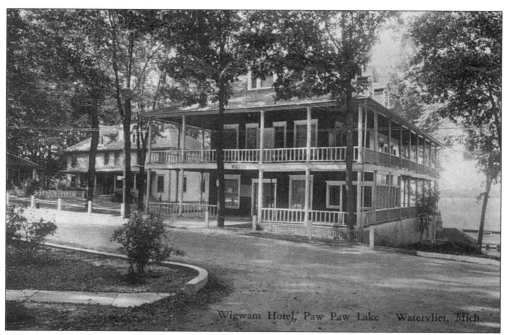

The Wigwam Hotel, like many of the hotels and cottages, did not have a restaurant on the premises. Later, they built a small café across the street to accommodate their guests. Notice the balcony surrounding the hotel on all four sides. It is still there today but privately owned, and is no longer used as a hotel.

Sailboats were only one type of boat seen on Paw Paw Lake. In the early days they used rowboats, canoes, and then double-decked steamers. Later, the inboard motorboats arrived, and in the 1930s, paddleboats were very popular. On any given day, you could probably find some kind of boat race happening from one of the pavilions.

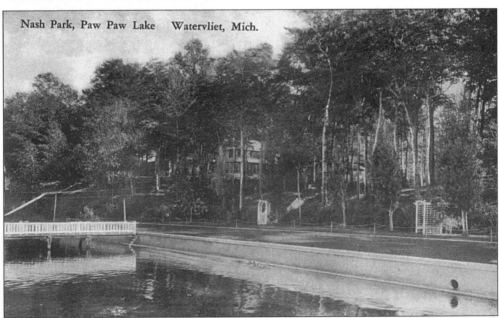

Nash Park was located near the Wigwam Hotel. P.A. Nash built a summer home that had extensive landscaped grounds. Located right on the lake, it was a wonderful place for a leisurely stroll on a summer evening.

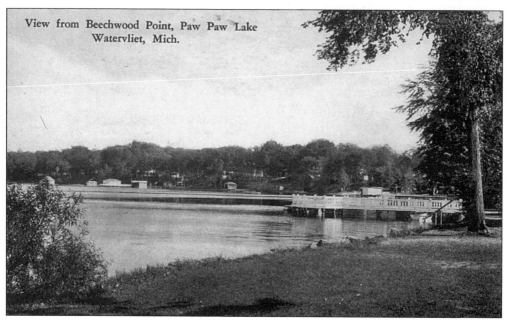

View from Beechwood Point, Paw Paw Lake
Watervliet, Mich.

The Beechwood Point Pavilion brings us back around Paw Paw Lake to Coloma Bay. Located directly across from the Woodward Pavilion, there was great rivalry between the two establishments. Woodward had an entrance from the shore's edge, but Beechwood was built entirely over the water. Each had a resident orchestra from Chicago that played for the season. Each had a master of ceremonies who entertained the guests as they led the evening's activities. With the windows open, the orchestras were encouraged to play louder. Their music flowed over the lake, and everyone else not at the pavilions could go outside on the porch, on the landings, or in a boat to enjoy the evening's festivities.

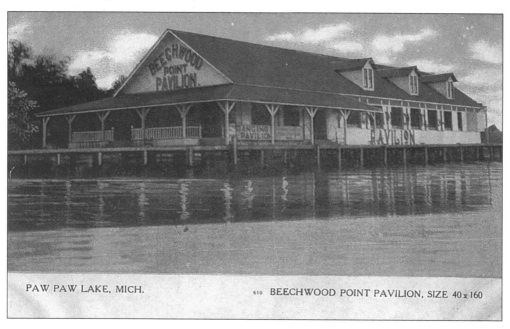

PAW PAW LAKE, MICH. 610 BEECHWOOD POINT PAVILION, SIZE 40 x 160

BIBLIOGRAPHY

Atwood, Harold A. *Historic Sites of Berrien County, Michigan*. Berrien Community Foundation, Inc., St., Joseph, MI, 1989.

Book of Remembrance. The What? Where? When? Why? And How? Of the House of David. House of David, Benton Harbor, MI, 1931.

Buchanan, Yesterday Today Tomorrow. Buchanan Public Schools, Buchanan, MI, 1990.

Carney, James T. *Berrien Bicentennial*. Berrien County Bicentennial Commission, 1976.

Coolidge, Judge Oliver W. *A Twentieth Century History of Berrien County, Michigan*. Lewis Publishing Company, Chicago, 1906.

Edmunds, Dwight, compiler. *Origins*. Pamphlet, Farmers & Merchants National Bank, 1976.

History of Brick School District No. 4 1841–1958. Patterson & Company Printers, Benton Harbor, MI, 1958.

Howland, Elvin. *Rails Across Michigan*. Zosma Publications, Cadillac, MI, 1999.

Kesterke, Forrest H., compiler. *Berrien County Directory 1969–1970*. Office of the County Clerk, St. Joseph, MI, 1969.

Krause, Fred. *Historic Old Saint Joseph, Michigan*. Privately Published, 1992.

Krieger, Mrs. Ray, ed. *The History of Brick School District No. 4 1841–1958*. Patterson & Company Printers, Benton Harbor, MI, 1958.

Myers, Robert C. *Historical Sketches of Berrien County*. The 1939 Courthouse Museum, Berrien Springs, MI, 3rd Printing, 1990.

Myers, Robert C. *Historical Sketches of Berrien County, Volume 2*. The Courthouse Museum, Berrien Springs, MI, 2nd Printing, 1997.

Myers, Robert C. *Historical Sketches of Berrien County, Volume 3*. The 1939 Courthouse Museum, Berrien Springs, MI, 1994.

Myers, Robert C. *Millennial Visions and Earthly Pursuits: The Israelite House of David*. Berrien County Historical Association, Inc., Berrien Springs, MI, 1999.

North Berrien Historical Society. *Glimpses of the Past, Stories and pictures of North Berrien pioneer families*. Tri-City Record, Watervliet, MI, December, 1992.

Rasmussen, Roderick L. *Paw Paw Lake, A 100 Year Resort History 1890s–1990s*. Southwestern Michigan Publications, Coloma, MI, 1994.

Rasmussen Roderick L. *Paw Paw Lake, Images of a Lake*. Southwestern Michigan Publications. Coloma, MI 1996.

Southwestern Michigan Tourist Council. Various pamphlets and printed information about Berrien County.

Souvenir History of Watervliet. Kiernan Publishing, Watervliet, MI., Facsimile Reprint, 1994.

Stark, Mabel Branch. *Trails from Shingle Diggin's*. R.W. Patterson Printing Co., Benton Harbor, MI, 1977.

Zerler, Glenn and Kathryn. *Blossomtime Festival Southwest Michigan, A Pictorial History 1906–1996.* Blossomtime Incorporated, Benton Harbor, MI, 1995.

Zerler, Kathryn S. *On The Banks of the Old St. Joe*. St. Joseph Today, St. Joseph, MI, 5th printing, 1994.

INDEX